Mark Powell-Jones

IMPRESSIONIST PAINTING

MAYFLOWER BOOKS
NEW YORK

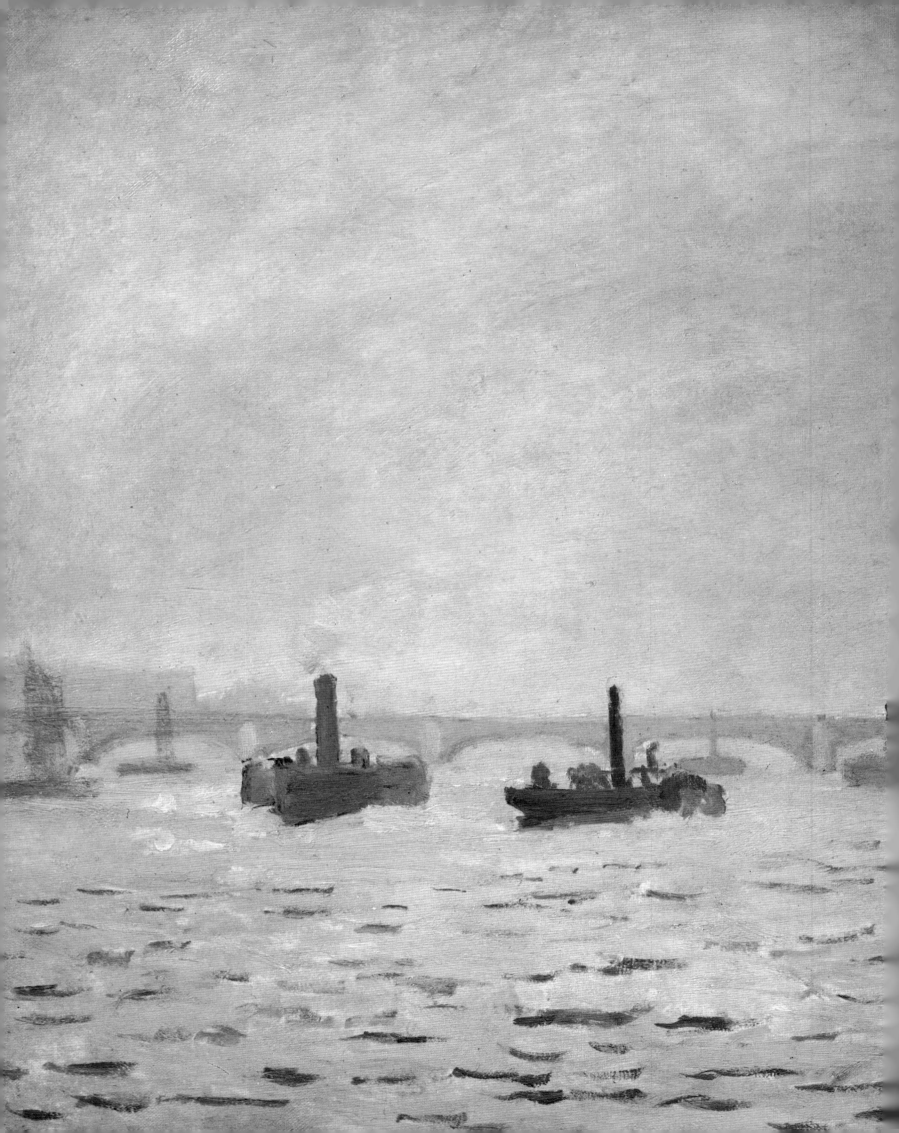

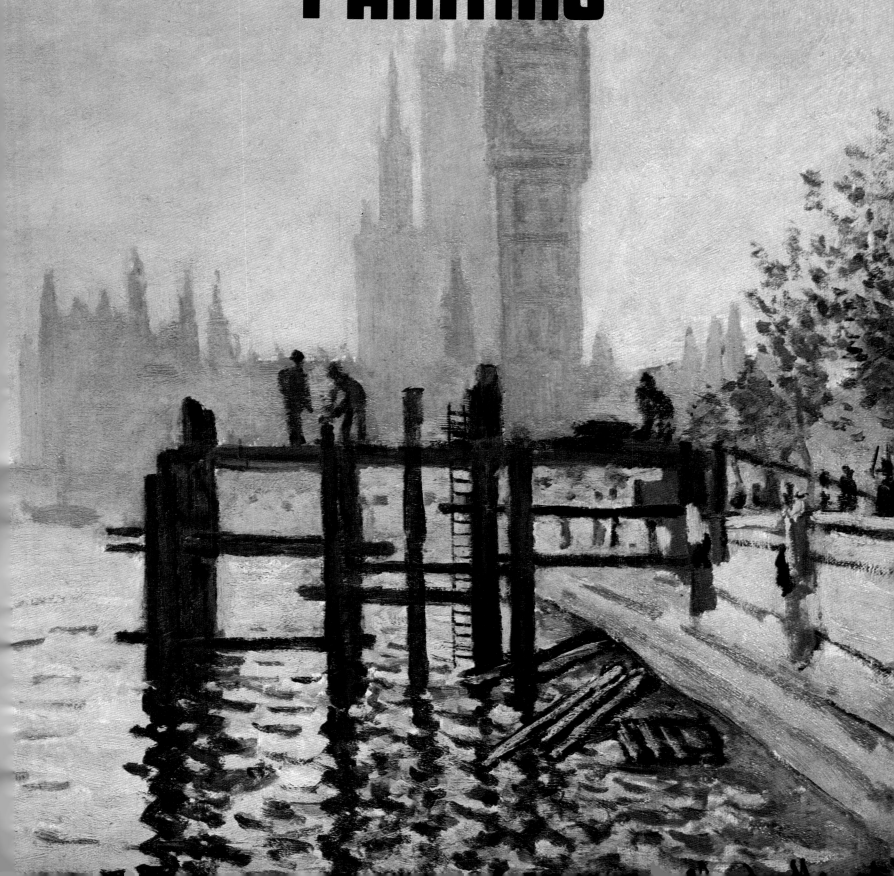

Mark Powell-Jones

IMPRESSIONIST PAINTING

For Erica Davies

OVERLEAF **Monet**: *The Thames below Westminster*, 47 × 73cm, 1871

MAYFLOWER BOOKS, INC.,
575 Lexington Avenue, New York City 10022.

First published 1979
© TEXT 1979 Phaidon Press Limited
© DESIGN 1979 Heraclio Fournier, S. A.

The film positives of the illustrations are
the property of Heraclio Fournier, S. A.

Library of Congress Cataloging in Publication Data

POWELL-JONES, MARK.
Impressionist painting.

1. Impressionism (Art) – History. 2. Painting,
Modern – 19th Century – History. I. Title.
ND192.14P68 759.05 78–25565
ISBN 0-8317-4893-1
ISBN 0-8317-4894-X pbk.

Filmset in England by SOUTHERN POSITIVES AND NEGATIVES
(SPAN), Lingfield, Surrey
Printed and bound in Spain by HERACLIO FOURNIER SA, *Vitoria.*
First American edition

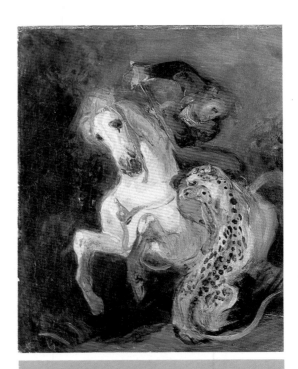

Above **Delacroix:** *Rider Attacked by a
Jaguar*, 29 × 24cm, 1850
Right **Courbet:** *Burial at Ornans*,
315 × 668cm, 1849–50

Delacroix and Courbet both belonged to
a movement in European painting that
was to be important in the development
of Impressionism. Delacroix was a hero
to younger generation of painters. His
use of bright colours and the freedom of
his brushstrokes led him to be con-
sidered an outcast by the followers of
Ingres, but exercised an influence on the
work of painters as diverse as Renoir
and Seurat.

Courbet, even more of an outcast
than Delacroix, tried to show in works
such as *Burial at Ornans* that ordinary
events and people could provide fit
subjects for monumental paintings. This
proposition was considered revolu-
tionary at the time, and the Impressionists
admired his stand against the establish-
ment.

Impressionist Painting

The Origins of Impressionism

THE ROOTS OF IMPRESSIONISM can be found in a number of different and apparently conflicting movements in thought and art. First and foremost, it sprang from the tradition of naturalism in the visual arts, from the idea that the painter's job is to produce a convincing image of reality. This apparently simple aim has within it an unresolved ambiguity: is the convincing image one that shows the world as the artist knows it to be, or is it one that shows it as he and others perceive it? Primitive societies, knowing that a man has two eyes, tend to demand that his image should always have two eyes as well. In the years leading up to the Renaissance, however, painters began to move towards painting scenes not as they knew them to be, but as they would appear from a particular viewpoint, so that a man in profile was shown with only one eye, and a man in the foreground was bigger than a castle in the background. The public, in short, were trained to accept the use of perspective, a convention that came to seem so natural that Europeans were quite surprised to find that to people outside their tradition a drawing of a table in perspective simply looked like a drawing of a crooked table. The achievement of the Impressionists was to match the revolution achieved in the Renaissance with regard to the representation of form by an equal revolution in the representation of colour. For the first time in the history of art they made a prolonged and concerted attempt to paint objects not the colour that we know them to be but the colour that we see them.

Naturalism was not, however, popular with the art establishment in France and elsewhere, which believed that mere problems about the representation of reality had been solved, once and for all, during the Renaissance. That being so, it was felt that the sacred duty of the artist was to search for and express in his painting the ideal, to bring into peoples' lives precisely that which is lacking in reality. Now traditionally the artist, like any other craftsman, had been at the service of the society in which he lived. Naturalism had flourished only when, as in seventeenth-century Holland, those who paid for the paintings were interested in the representation of reality. The extraordinary decision of the Impressionists to produce work for which not only was there no strong demand, but towards which the public felt active hostility and contempt, can be explained only by reference to the effect of Romanticism.

The Romantics were not in the least concerned with mundane reality but they did have strong and influential views on the relation of the individual to society and to nature.

Courbet: *Burial at Ornans,* 315 × 668cm, 1849–50

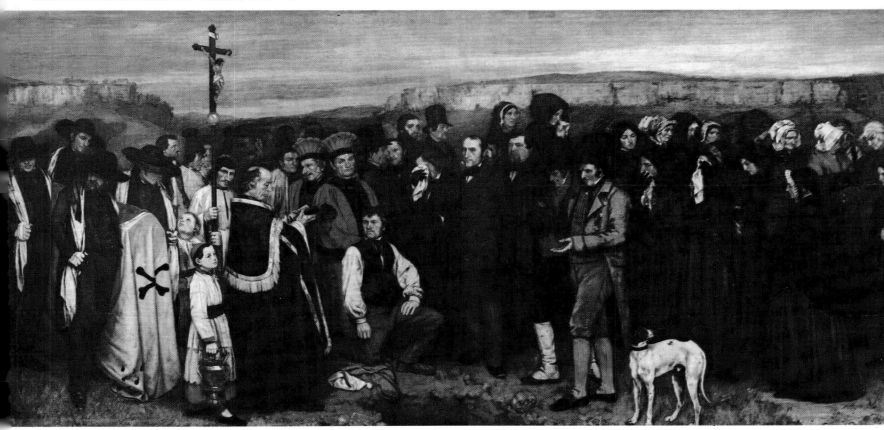

Impressionist Painting: **Corot**

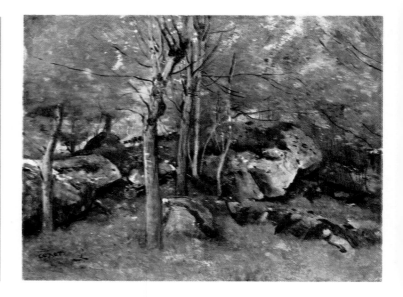

Corot: *Rocks in the Forest of Fontainebleau*
Corot: *The Forest of Fontainebleau*
Corot: *Civita Castellana*

Corot visited Italy in 1825–8 and again in 1834. He stayed frequently in the region of Fontainebleau, and was closely associated with the Barbizon school of landscape painters. His devotion to nature and desire to be faithful to his observations were the qualities in his art that attracted the Impressionists. His advice to students was to submit to the first impression, but he did not achieve this immediacy until late in his career, and he always completed pictures intended for exhibition in the studio. Berthe Morisot painted with him in the open air in 1863.

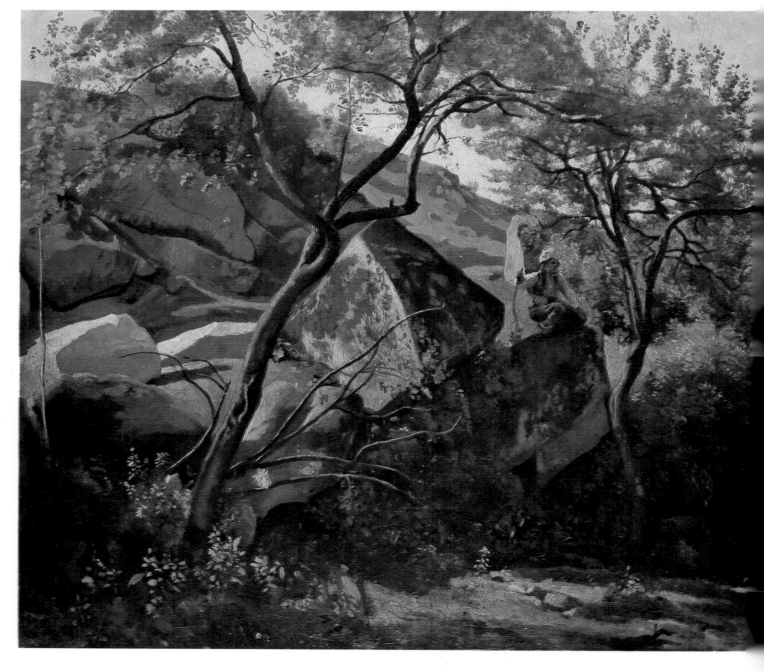

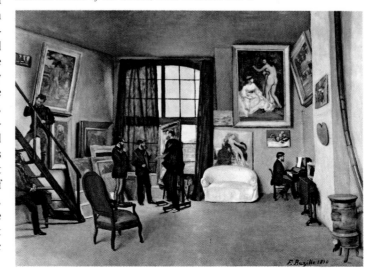

LEFT **Corot:** *Rocks in the Forest of Fontainebleau,*
46 × 59cm, 1860–5

LEFT, BELOW **Corot:** *The Forest of Fontainebleau,*
29 × 43cm, c.1850

RIGHT **Corot:** *Civita Castellana,* 36 × 51cm,
1826–7

BELOW **Manet:** *Portrait of Émile Zola,*
146 × 114cm, 1867–8

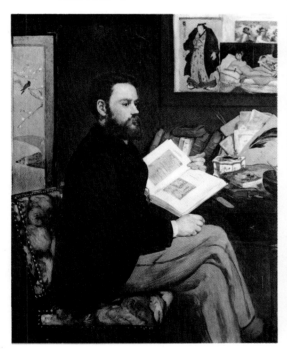

Manet: *Portrait of Émile Zola*
Bazille: *Studio of the Artist*

Manet's *Portrait of Émile Zola* and Bazille's *Studio of the Artist* show
some of the most important figures in the Parisian avant-garde in the
late 1860s. Émile Zola was one of the first and most influential
defenders of Manet's work. A childhood friend of Cézanne, he was
initially friendly to the Impressionist's efforts. However, *'L'Oeuvre'*, a
novel published in 1886, the hero of which was based on Cézanne,
was seen as demonstrating a lack of faith in their work, and Monet
wrote to him that he feared that 'our enemies may make use of this
book to deal us a knockout blow'. The portrait shows Manet's
preference for painting with the light behind his head, so that the
object in view is flattened, obviating the need for modelling. A
Japanese print and an engraving of Manet's *Olympia* can be seen in
the frame above Zola's desk. Such prints were to provide a con-
tinuing source of inspiration for the Impressionists, influencing the
way they used colour, line and space.

Bazille's studio in the rue de la Condamine is the scene for this
group portrait painted in the same year as his tragically early death.
Zola is leaning over the stairs talking to Renoir, while Monet inspects
the canvas on the easel and Manet stand beside him. The figure of
Bazille with palette and brushes in hand was painted in later by Manet.

They expressed what were, in terms of established European
thought, two revolutionary views. The first was that an
individual's personality was of an importance that tran-
scended any limitations imposed by his place in the social
hierarchy, and that it was not only permissible, but in some
way rather heroic, to hold views that went clean contrary
to accepted opinion. From this followed the concept of the
noble outcast, misunderstood and mistreated by society,
which made being heroic in this sense a position that pre-
vious generations would have regarded as both pitiable and
laughable. The second was that nature is admirable not, as
previous generations had tended to believe, in so far as it
had been ordered by man, but in and for itself. So, if
naturalism provided a tradition and an unresolved problem,
Romanticism provided an attitude towards nature that made
study of it seem desirable, and a self-image for the artist that
made it possible for him to pursue it even in the face of public
hostility.

Bazille: *Studio of the Artist,* 98 × 129cm, 1870

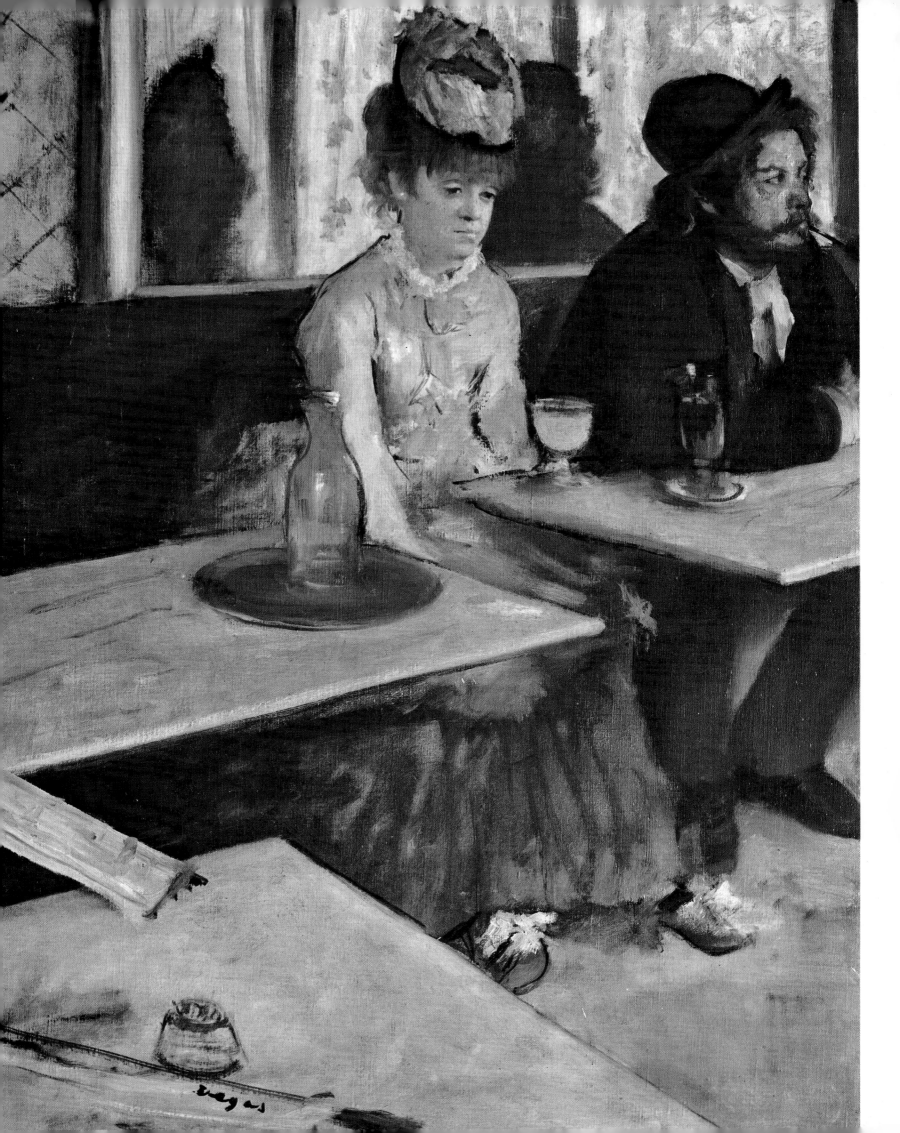

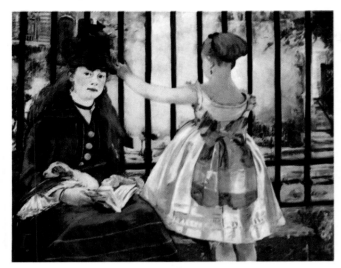

Manet: *The Railway*, 93 × 115cm, 1873

Bazille's *Family Reunion*, Manet's *The Railway*, Degas's *Absinthe* and *The Orchestra of the Opera* show different aspects of the painting of contemporary life that literary figures like Baudelaire, the Goncourt brothers and Zola had been calling for in the previous decades. All of them depict the friends or family of the artist. Bazille painted members of his family at his parents' estate near Montpellier; although he began in the open air, this painting was completed in the studio. It was accepted for the 1868 Salon. Manet, like Turner and Monet, found the railway an exciting subject, one of the wonders of modern technology. *L'Absinthe* shows a scene at the café called the 'New Athens' in the Place Pigalle, which from 1876 onwards was one of the Impressionists' meeting places.

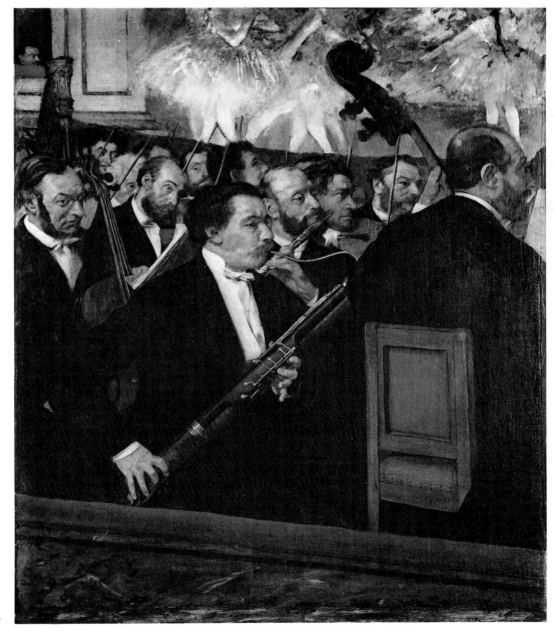

LEFT **Degas:** *Absinthe*, 92 × 68cm, 1876–7

RIGHT **Degas:** *The Orchestra of the Opera*, 56 × 46cm, 1868–9

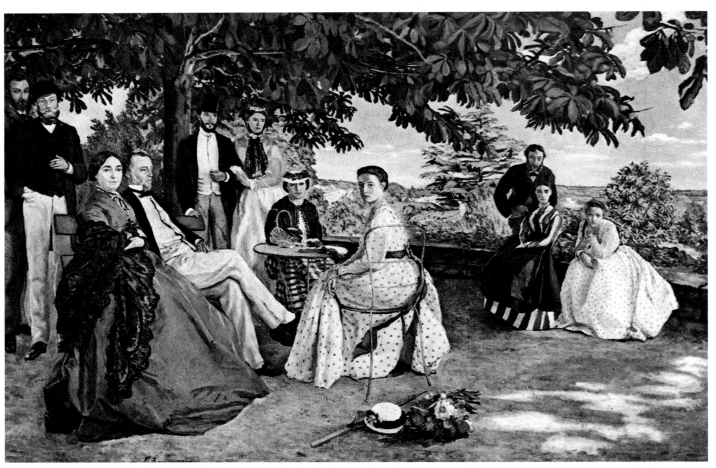

Bazille: *Family Reunion,* 152 × 230cm, 1867

Courbet and the Barbizon School provided a third essential element in the birth of Impressionism – an actual, living example of painters who had already set out on such a path. Courbet, who in his art and opinions totally rejected both Romanticism and Idealism, was nevertheless the epitome of the romantic outcast. In works like *Burial at Ornans* he not only had taken it upon himself to represent ordinary people (who were about as likely to be found in the canvases of respectable painters as in the drawing rooms of polite society); but he also outraged even those who were prepared to accept the sentimentalized poverty of the peasants in the work of a painter like Millet, by showing the peasants as they actually were. Such outrage derived from a belief, shared equally by Courbet and the regime – which he as a revolutionary republican loathed – that to allow that common people were a fit subject for art was to imply that they were fit to govern, and that to show up official art as a sham was to imply that the structure of the regime was one too. From Courbet's example artists learnt that the representation of reality was not simply a technical exercise, but rather an activity with considerable social and intellectual implications. They also learnt that an artist could take on society and win at least widespread notoriety, and the admiration of a select few.

The Impressionists were not, however, much attracted by Courbet's subject-matter or technique. It was Corot and the Barbizon School who provided an example of painters working towards a sincere understanding of nature. Their work did not in any sense represent a revolution in the history of landscape painting. Turner had demonstrated a more daring approach to problems of atmosphere, by painting the effects of light and mist, and even the Barbizon School's emphasis on work in the open air had been anticipated by the English landscape school. Yet it was these painters that the Impressionists looked up to with admiration, and it was from them and, in Monet's case, Boudin and Jongkind, that they took their subject matter and approach.

Jongkind: *The Ruins of the Château de Rosemont*
Boudin: *The Pier at Deauville*
Boudin: *The Port of Antwerp*

Jongkind and Boudin both influenced the young Monet. Boudin was a delicate painter and a sharp observer of the changes in sea and sky at different times of the day and different seasons. He felt that it was important to show the 'extreme stubbornness in retaining one's first impression'. A conviction which Monet came to share when they painted together in 1858–9. Jongkind was a Dutch painter who spent much of his life painting in the Seine estuary. He met Monet in 1862 on Monet's return from Algeria. Although, unlike Boudin, he did not finish his canvases in the open air, his bold approach to nature had a strong effect on the younger painter's work in the early 1860s.

Jongkind: *The Ruins of the Château de Rosemont,* 34 × 57cm, 1861

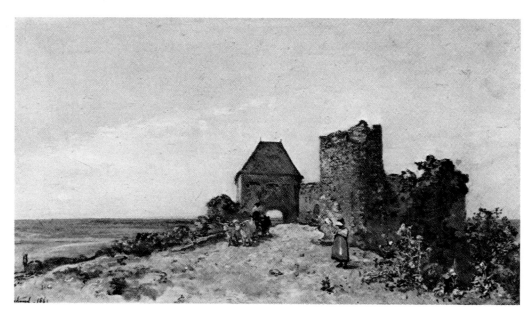

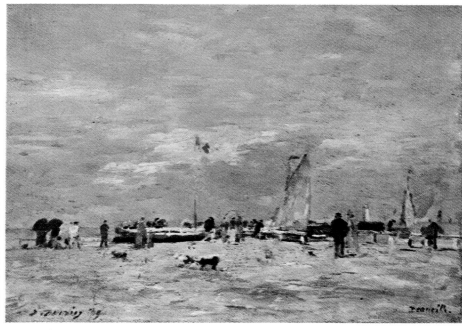

Boudin: *The Pier at Deauville,* 24 × 33cm, 1869

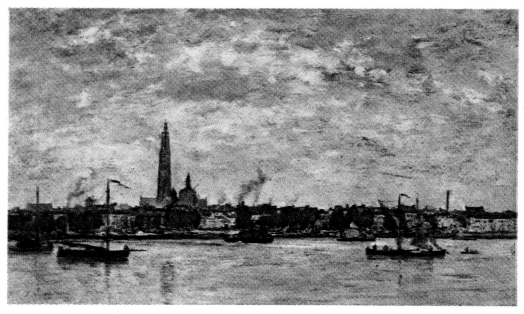

Boudin: *The Port of Antwerp,* 41 × 66cm, 1871

OVERLEAF **Pissarro:** *View of Pontoise,* 52 × 81cm, 1868

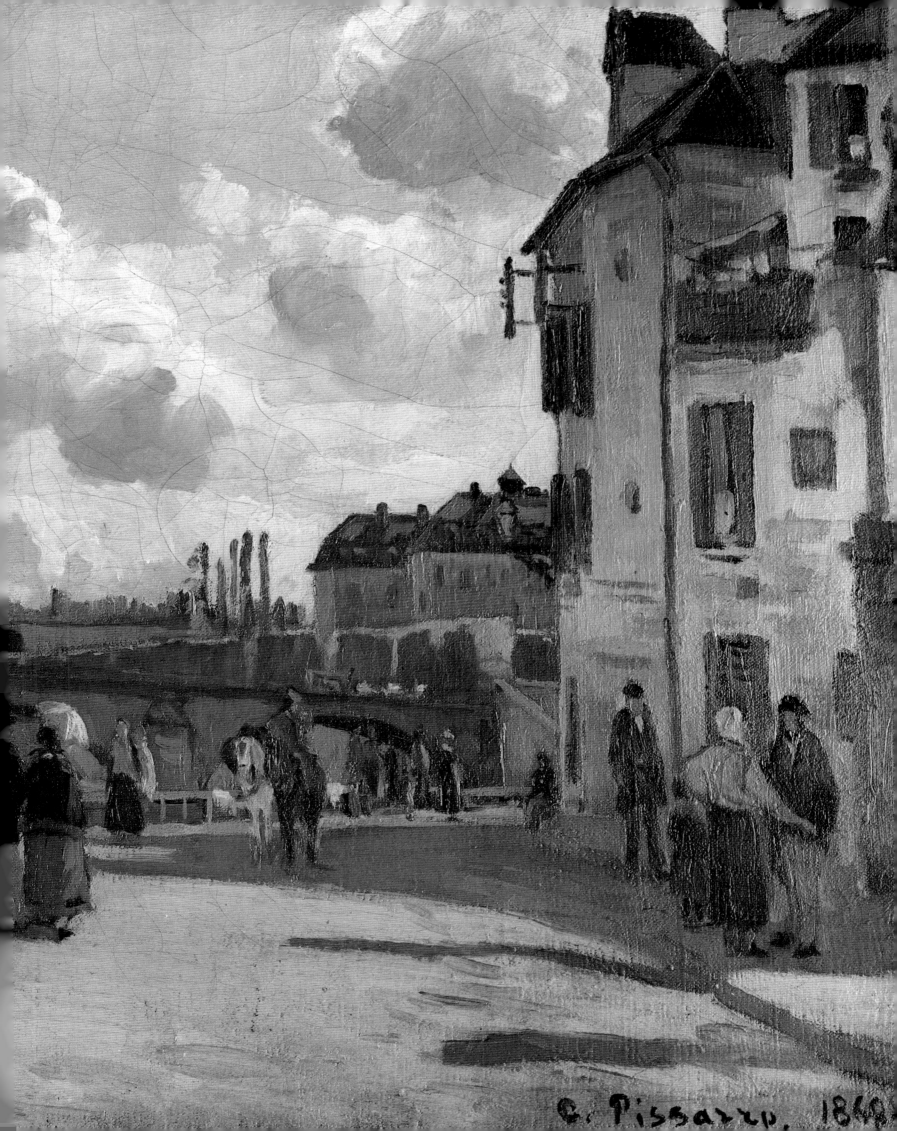

C. Pissarro. 1868.

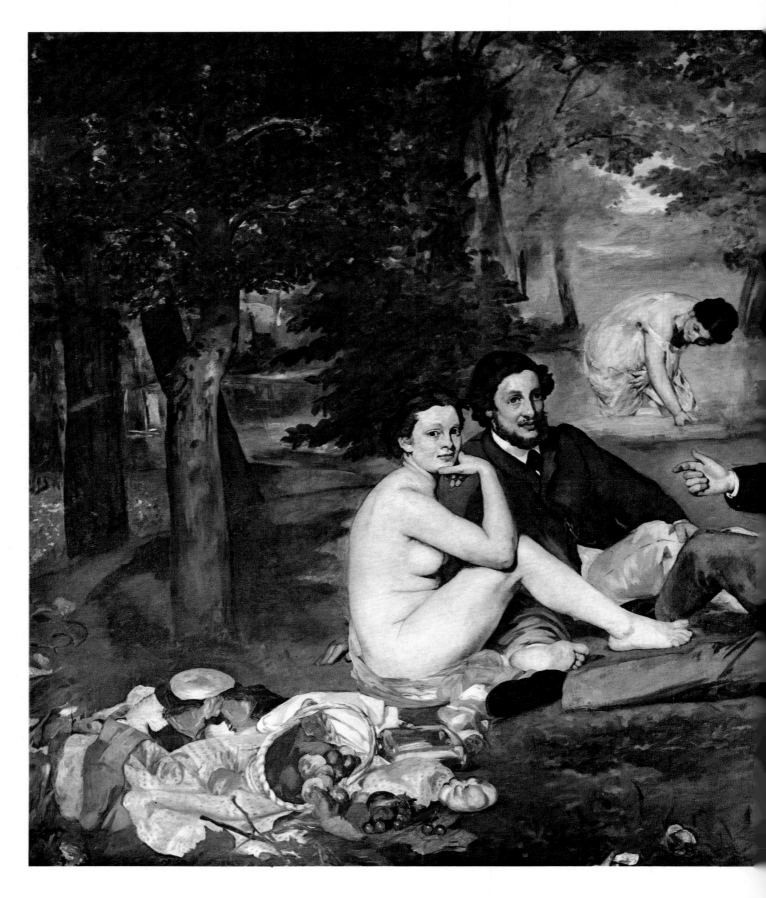

The Early Years

Monet was, from the beginning, the dominant force in the development of Impressionism. It was his profound love of nature and his obstinate belief in the importance of finding the most perfect way of rendering its appearance on canvas that set and kept his friends on the path towards Impressionism, and it was he who continued to develop it with the greatest tenacity right to the end of his life.

Claude Monet was born in 1840 and grew up at Le Havre in Normandy. His talent, rather ironically in view of the fact that his later work showed little or no interest in the human face, first showed itself in juvenile caricatures. These were so successful that he was able to sell them in the shop of a picture-frame maker, and there in 1858 he met Eugène Boudin. Although Monet initially detested the older artist's seascapes he finally accepted his invitation to go sketching in the country. It was in the country, he later recalled, 'My

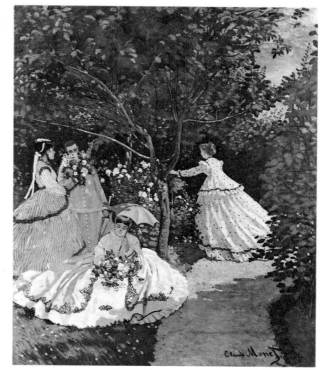

ABOVE **Monet**: *Women in the Garden*. 255 × 205cm, 1866

LEFT **Manet**: *Le Déjeuner sur l'Herbe*, 208 × 265cm, 1863

BELOW **Monet**: *Le Déjeuner sur l'Herbe* (fragment), 418 × 150cm, 1865

Manet: *Le Déjeuner sur l'Herbe*
Monet: *Le Déjeuner sur l'Herbe* (fragment)
Monet: *Women in the Garden*

Manet's *Le Déjeuner sur l'Herbe* was exhibited at the *Salon des Refusés* in 1863. It caused a great scandal and Louis Napoleon proclaimed it 'indecent'. A society which found the female nude acceptable when posed in classical surroundings was horrified at this naked woman, accompanied by two fully clothed men, staring so calmly at the observer.

Manet's picture had obviously been painted in the studio and Monet set out to demonstrate in his own *Le Déjeuner sur l'Herbe* how figures would really look in a rural setting. He worked at Chailly-en-Bière at the edge of the Forest of Fontainebleau and Bazille posed for him. Eventually he abandoned the work. When he went back to it, years later, part of it had rotted and it was cut up. *Women in the Garden*, his second attempt, was painted entirely in the open air, from a special trench dug for the occasion. Camille, Monet's mistress, posed for all the figures. Perhaps partly because of Courbet's adverse criticism of his work and partly because of the labour involved, Monet showed little interest in large figure composition after this date.

eyes were finally opened and I really understood nature: I learned at the same time to love it.'

In 1859, at Boudin's suggestion, Monet went to Paris. He decided to remain there in order to become a painter but, with a radical arrogance almost unbelievable in a half-educated young provincial, declined to take what was then the only recognized training at the École des Beaux-Arts. Instead, he continued to study landscape and started to draw the nude at a private establishment, the Académie

Renoir: *La Grênouillère*
Renoir: *On the Terrace*
Sisley: *L'Ile de Grande-Jatte*

The effect of light reflected in water was to be a constant theme in Impressionist painting. In 1869 Renoir worked with Monet at La Grênouillère, a popular boating and bathing place in the outer suburbs of Paris. Here they pursued their discovery that shadows are not brown or black, but are coloured by their surroundings. To reproduce this effect they used pure, unmixed colours. Ten years later Renoir used the river as a background for the charming *On the Terrace*, which also contains others of his favourite subjects, flowers, a pretty girl and a child. Sisley returned time and time again to the theme of water. This painting demonstrates his particular feeling for cloudscapes and for the cold clear light of winter.

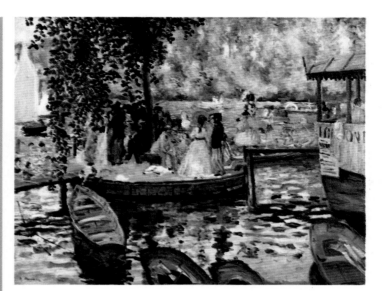

Renoir: *La Grênouillère*, 66 × 81cm, 1868–9

Suisse. In 1860 he was drafted to Algeria as a conscript in the French army.

In 1862 Monet, who said later that 'the impression of light and colour' that he had received in Africa 'contained the germ of my future researches', became ill and was bought out of the army. At home in Le Havre in the summer of that year he met the Dutch painter, Johan Barthold Jongkind. 'From that time', Monet recalled, 'he was my real master . . . it was to him that I owe the final education of my eye,' and indeed Monet's land- and seascapes of the 1860s are closer in their boldness and solidity to Jongkind's than to Boudin's relatively timid work.

Monet's father insisted that if he wanted an allowance he must enter the studio of a successful painter. Reluctantly he agreed, and went to work under Charles Gleyre, the most popular and lenient of the academic teachers. There he met Frédéric Bazille, a rich young man from the south of France, Alfred Sisley and Auguste Renoir.

Renoir was unique among the Impressionists in coming from a poor family, and in having grown up in the poorer quarters of central Paris. He was apprenticed as a painter of

porcelain, and when the business closed down, he managed to earn good money by painting blinds and mural decorations in cafés. By the age of twenty-one he had earned enough to keep himself as an art student, and passed the entrance exams for the École des Beaux-Arts with high marks. He settled down to work in Gleyre's studio, where, as he later recalled, 'I stayed quietly in my corner, very attentive, very docile, studying the model, listening to the master.' Indeed had it not been for his unacademic love of bright colours and the disturbing influence of Monet, Renoir and his fellow pupils, Sisley, who intended to compete for the Prix de Rome, and Bazille, all might have become successful establishment painters.

In 1863 Henri Fantin-Latour, impressed by the fluency of Renoir's talent, first led him out of the studios. 'You can never copy the masters enough,' he told him, and sent him off to the Louvre. Monet preferred a different avenue of escape and set out with Bazille to paint in the country, at Chailly on the edge of the Fontainebleau forest near Barbizon. In the following year he went again to Chailly, this time bringing with him Renoir and Sisley as well as Bazille. This

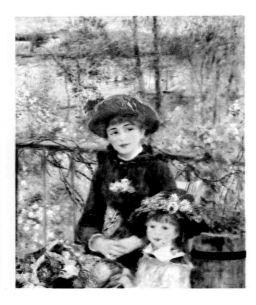

LEFT **Renoir:** *On the Terrace*, 100 × 81cm, 1879

RIGHT **Sisley:** *L'Ile de Grande-Jatte*, 51 × 65cm, 1873

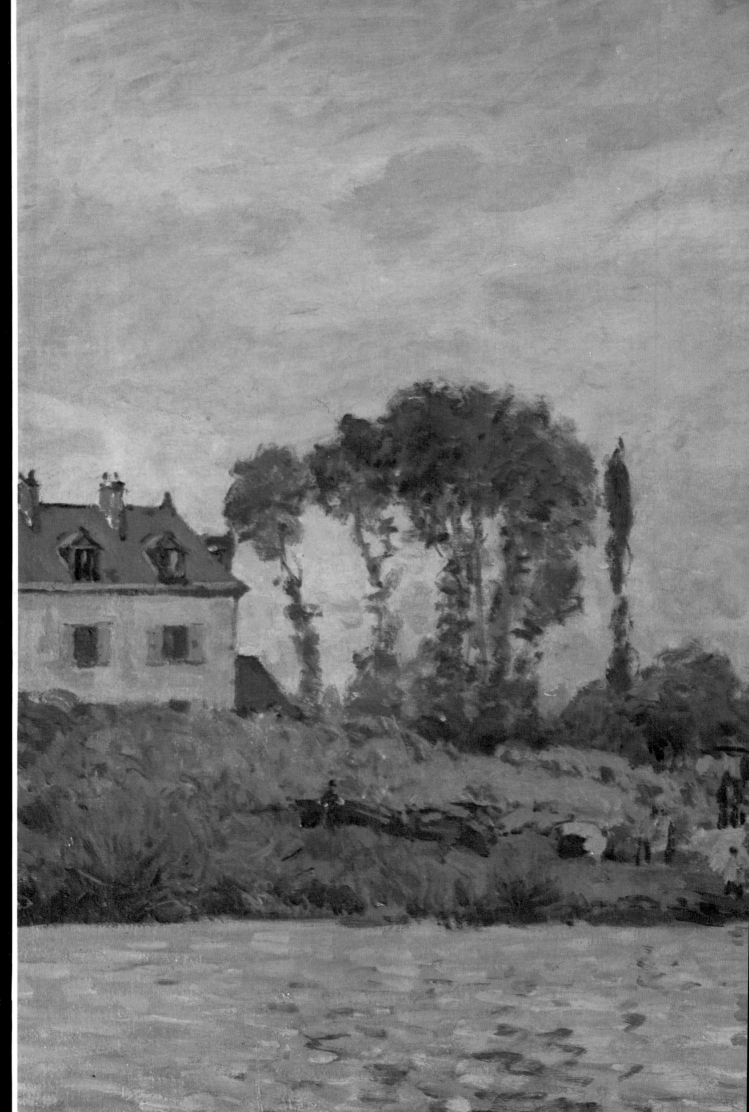

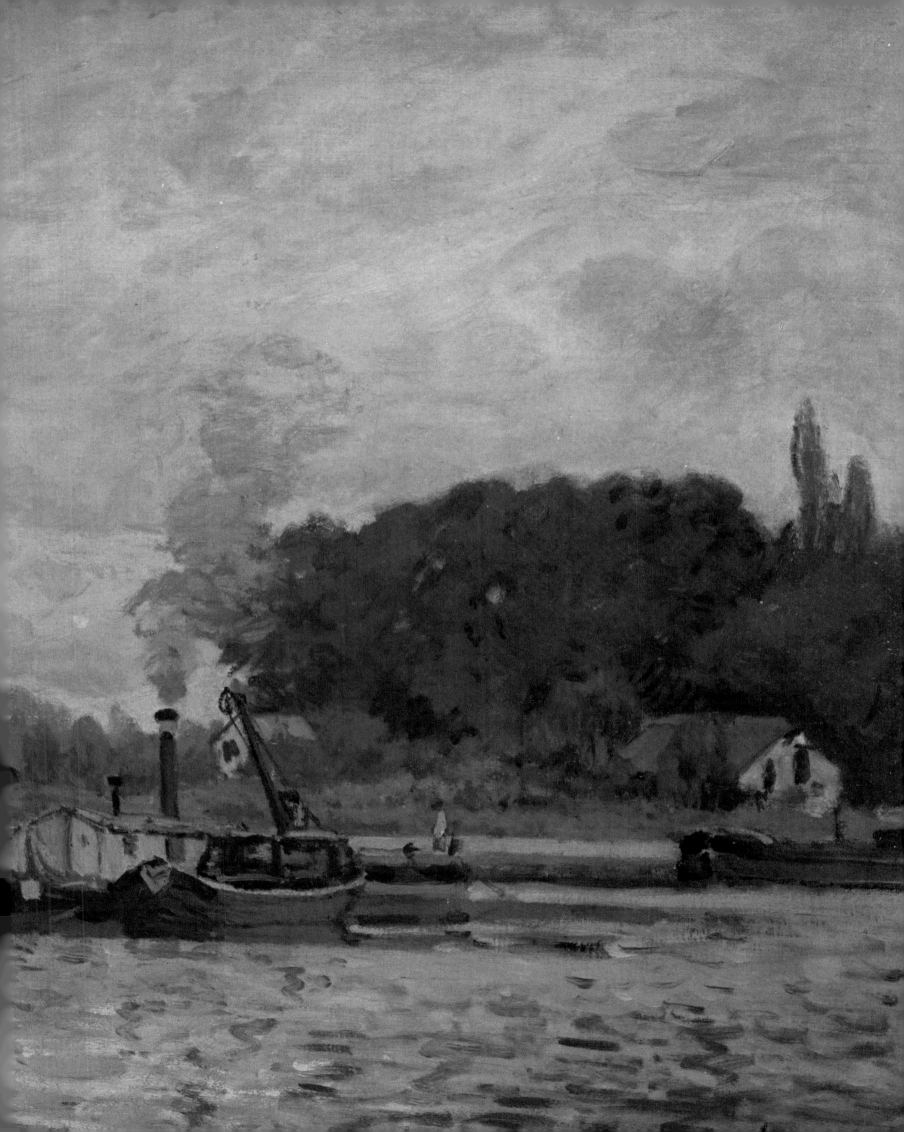

Pissarro: *Lower Norwood, London, Effect of Snow*
Pissarro: *Entrance to the Village of Voisons*
Pissarro: *Village near Pontoise*
Sisley: *The Chemin de Sèvres*

During the Franco-Prussian War Pissarro and Monet fled to England. While Monet chose to paint such famous places as Hyde Park, Pissarro found inspiration in the suburb of Norwood, where he lived. Under the influence of Monet, Pissarro's style developed rapidly, his technique became looser and his colours lighter. On his return to France he went back to Louveciennes and his view of a nearby village, Voisons, shows his particular delight in receding perspectives. Later in the same year he moved to Pontoise, where the surrounding landscape was to provide the inspiration for most of his paintings in the 1870s.

Sisley remained in France and after the war settled near Paris. He selected a view of Sèvres very like Pissarro's. Their choice of subject can be traced to Corot, who had a particular preference for views of tree-lined roads.

was their introduction to nature, and, under the influence of Monet and of Diaz, a Barbizon painter with whom Renoir made friends, they began to develop an interest in landscape.

Back in Paris it was the work of Edouard Manet that exerted the greatest influence on the young painters. Manet, after the considerable success of his *Guitar Player* at the salon of 1861 was refused, along with a large number of other painters, at the Salon of 1863. The resulting outcry led to the opening of the *Salon des Refusés*, at which he showed a painting entitled *Le Déjeuner sur l'Herbe*. This, by showing naked women, not in a safely allegorical context, but having a picnic in the country with men clothed in contemporary dress, caused considerable scandal. It also identified Manet in the public's mind as the leader of radical tendencies in art.

RIGHT **Sisley**: *The Chemin de Sèvres*, 55 × 73cm, 1873

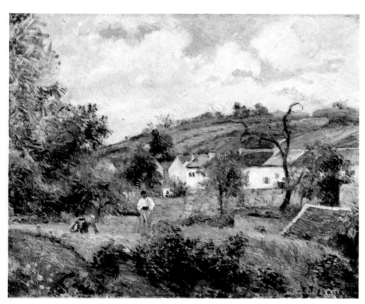

Pissarro: *Village near Pontoise.* 55 × 65cm. 1873

Le Déjeuner sur l'Herbe interested Monet, not for the scandal it caused, but because it highlighted, although failed to solve, the problems of integrating figures into landscapes painted in the open air. These problems he set out to solve in 1865 and 1866 in a series of studies for a painting to which he gave the same title.

In the late 1860s, Monet and Renoir also became interested in painting scenes of Paris. To an extent these also reflected the influence of Manet, who in the *Music in the Tuileries* had provided the most successful answer yet to Baudelaire's plea for a 'painter of modern life'. They also show the effect of the work of photographers like Nadar. For in these cityscapes, as in photographs, scenes are taken from unexpected angles, and people are represented as stick-like figures, more part of the urban scenery than individuals. The programme for the painter of modern life laid out by the literary critics was, however, like all programmes, anathema to the essentially pragmatic approach of the Impressionists. It was left to artists standing rather apart from the mainstream of Impressionism, like Manet himself and above all Degas, to capture the beauty of contemporary Parisian life.

The Development of Impressionism

It was during the years immediately before and after the Franco-Prussian war and the Commune that Monet, Renoir, and Pissarro developed that approach to the representation of open-air scenes that came to be termed 'Impressionism'. Having studied the background of the participants in this development, it is time to turn to an examination of this approach and how it evolved.

Fundamental to the development of Impressionism was the belief that the sensation received in the open air, before the motif, was of primary importance, and that to work up a landscape in the studio was inevitably to dull and even falsify the impression obtained on the spot. Monet, following the example example of Boudin was, as we have seen, the first of the group to realize the virtues of this approach. It was he who introduced his friends to it and who maintained their faith in its value. As a result of working in the open air, Monet and his friends became increasingly convinced that the sombre coloration and brown shadows sanctioned by traditional landscapists were untrue to nature. In an effort to purify and brighten his colours Monet, following the example of Manet, began to prime his canvas with a white ground instead of with the sombre base used by even so

Monet: *Boats at Argenteuil*
Monet: *Vétheuil*

On his return from England, Monet settled at Argenteuil, on the Seine near Paris, where he lived from 1872 until 1876. There he painted numerous views of the river, often from a floating studio, which he probably built with the help of Gustave Caillebotte, a neighbour and boating enthusiast who was to become a friend and patron of the Impressionists. Renoir and Sisley visited Monet and the work they produced marks one of the high points of Impressionism. This picture shows the loose, free manner and pure, clear colours that Manet used to depict reflections in the dancing water.

In 1878 Monet left Argenteuil for Vétheuil, where he stayed until 1882. He painted many views of the village from across the river, at all seasons of the year, and when the river froze over, he dug his easel into the ice.

LEFT **Monet:** *Vétheuil.* 90 × 93cm.

BELOW **Monet:** *Boats at Argenteuil.* 58 × 75cm. c.1872–3

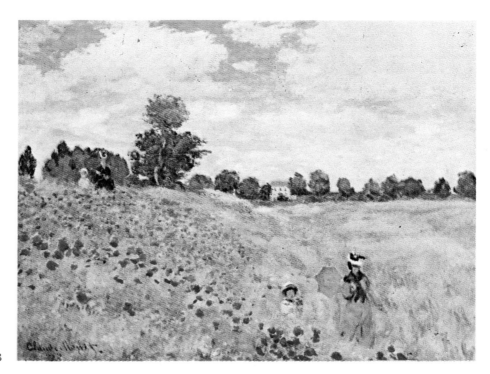

Monet: *The Poppies.* 50 × 65cm, 1873

radical a painter as Courbet. Renoir, with his innate love for bright colours, and Pissarro, who proclaimed that it was necessary to use only the three primary colours and their derivatives, also moved towards a brighter palette.

Through their close and continuous observation of nature, Monet and Renoir became aware that shadows are in fact coloured by the objects around them, and in Monet's *Terrace at the Seaside* and Renoir's *Lise,* both of 1867, this knowledge is already apparent. In order to develop it they liked to work on snow scenes, for snow being pure white, and thus colourless, has the advantage of showing up with particular clarity the colours that are reflected on to it.

In the struggle to represent nature as it is perceived, rather than as we know it to be, Monet, Renoir, Pissarro and their friends tried to be as humble as possible before it. They wanted to allow nature to speak through them rather than impose their preconceived ideas on it. Paintings must, they felt, record not, for example, a tree, a winding road and

Renoir: *The Path through the Tall Grasses.* 60 × 74cm, 1876–7

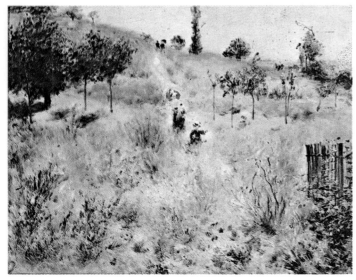

some rooftops, but those impressions received from them, which would in turn be interpreted by the viewer in the same way that he would interpret the impressions received directly from the scene. In the past a painter interpreted and then painted the impressions he had received as objects. Now the painter would renounce the act of interpretation and paint only the impression.

In an effort to rid themselves of the tendency to think in terms of delineating objects with lines, which resulted from the artist's pre-emptive interpretation of what he saw, the Impressionists needed to select subjects to which a linear approach was clearly inapplicable. As snow showed up the impossibility of the colourless shadow, so water, mist, masses of blossom, or grass rippling in the breeze showed up that of the outline. Working at La Grenouillère, a popular bathing place near Paris, and, after the war, at Argenteuil, Monet and Renoir grew close to each other both in style and subject matter, as shown by Renoir's *La Grenouillère* and *Path through the Tall Grasses* and Monet's *Boats at Argenteuil* and *Poppies.* Increasingly, in the attempt to represent ever-

Renoir: *The Path through the Tall Grasses*
Monet: *The Poppies*

Renoir's *Path through the Tall Grasses* and Monet's *Poppies* demonstrate some of the features that unified the Impressionists. Both artists have chosen a summer's day as their subject. They both use and revel in the bright, clear, bold colours of summer. They also punctuate the rolling fields on the one hand and the grassy path on the other with small figures, adding life and movement to the scene. Monet was obviously taken by the contrast of complementary colours provided by the red poppies in a green field and Renoir added a bright red parasol to achieve the same effect in his painting.

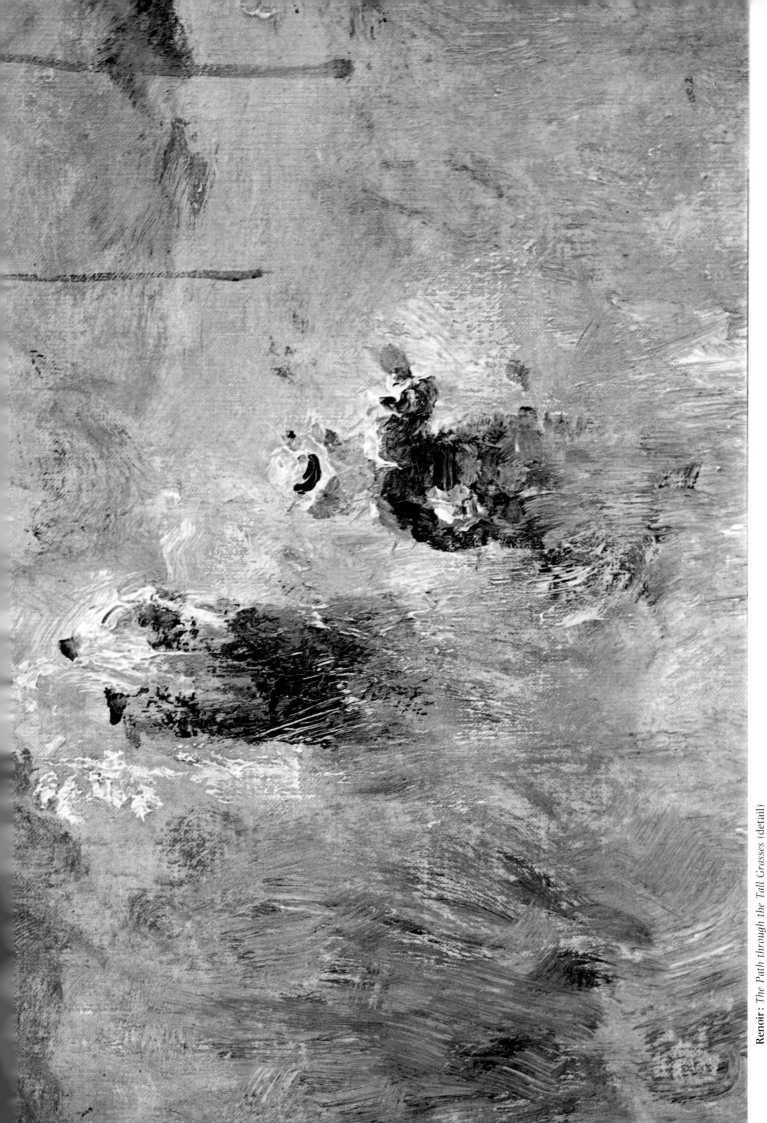

Renoir: *The Path through the Tall Grasses* (detail)

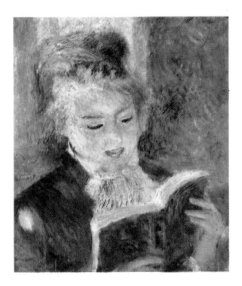

RIGHT **Renoir**: *Le Moulin de la Galette*, 131 × 175cm, 1875–6

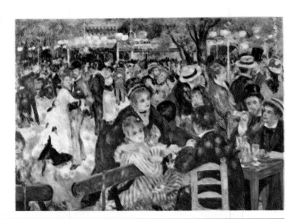

LEFT **Renoir**: *The Reader*, 47 × 39cm, 1874–6

changing reflections in the ripples of the water they preferred to use short and even comma-like brush strokes. Using these to place small, pure dabs of colour side by side, they were able to create on canvas the vibrant interplay between different colours that direct as well as reflected light produces in nature. Through this technique they were able to take as their subject not the objects themselves, but the light and atmosphere that surround objects, thereby giving their works a unity that was quite independent of composition.

The development of Renoir's and Monet's work was ob-

Renoir: *The Swing*, 92 × 73cm, 1876

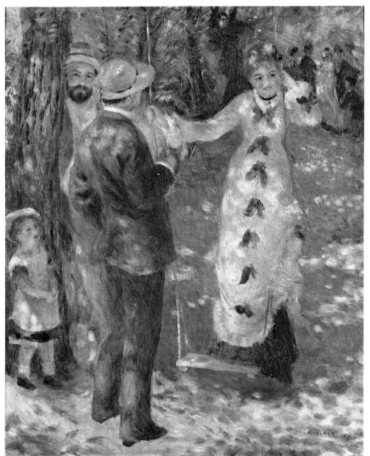

Renoir: *The Reader*
Renoir: *Le Moulin de la Galette*
Renoir: *The Swing*
Renoir: *The Umbrellas*

The three earlier paintings of this group show how Renoir was exploring the effect of different forms of light in the 1870s. In *The Reader* he used artificial light to illuminate his subject and conveyed its warm tones by highlighting the painting with dashes of red. In the two outdoor paintings he sought to capture the effect of the sunlight shining through the trees, producing a dappled effect on the figures below. He painted *Le Moulin de la Galette* at the public dance hall of that name. His friends posed for the larger figures, yet he has captured the flow and rhythm of the dancers and the gaiety of the occasion with the natural sympathy of one who came from the same background as the clientele.

The Umbrellas shows the effect of Renoir's dissatisfaction with Impressionism in the early 1880s. He worked and reworked it over a number of years, placing strong emphasis on the line which he felt he had neglected during his earlier career. Unhappy with the rather dry effect that this approach produced he later abandoned it and returned to a more fluid and painterly brushstroke.

served and appreciated by their friends. After Pissarro had met and painted with Monet in London during the war, his work, such as *Lower Norwood, London, Effect of the Snow, Entry to the Village of Voisons, Village near Pontoise*, and *The Red Roofs* moved strongly in the direction that Monet's work had taken, though retaining a feel for construction and for the solidity of things that was his own. Sisley and Berthe Morisot also moved away from the influence of Corot toward a fully Impressionist approach, as shown by Sisley's *L'Ile de Grande-Jatte* and *The Road Seen from the Chemin de Sèvres*, and Morisot's *Field of Corn* and *In the Garden*, and even Manet when he visited Monet at Argenteuil in 1874 followed their example.

The Impressionist Exhibition

The great advances toward a new style of painting on the one hand, and their increasing age (most of them were in their thirties) and family responsibilities on the other, made it seem more and more imperative to the Impressionists that their work should be seen, and preferably bought, by the

OPPOSITE **Renoir**: *Le Moulin de la Galette* (detail)

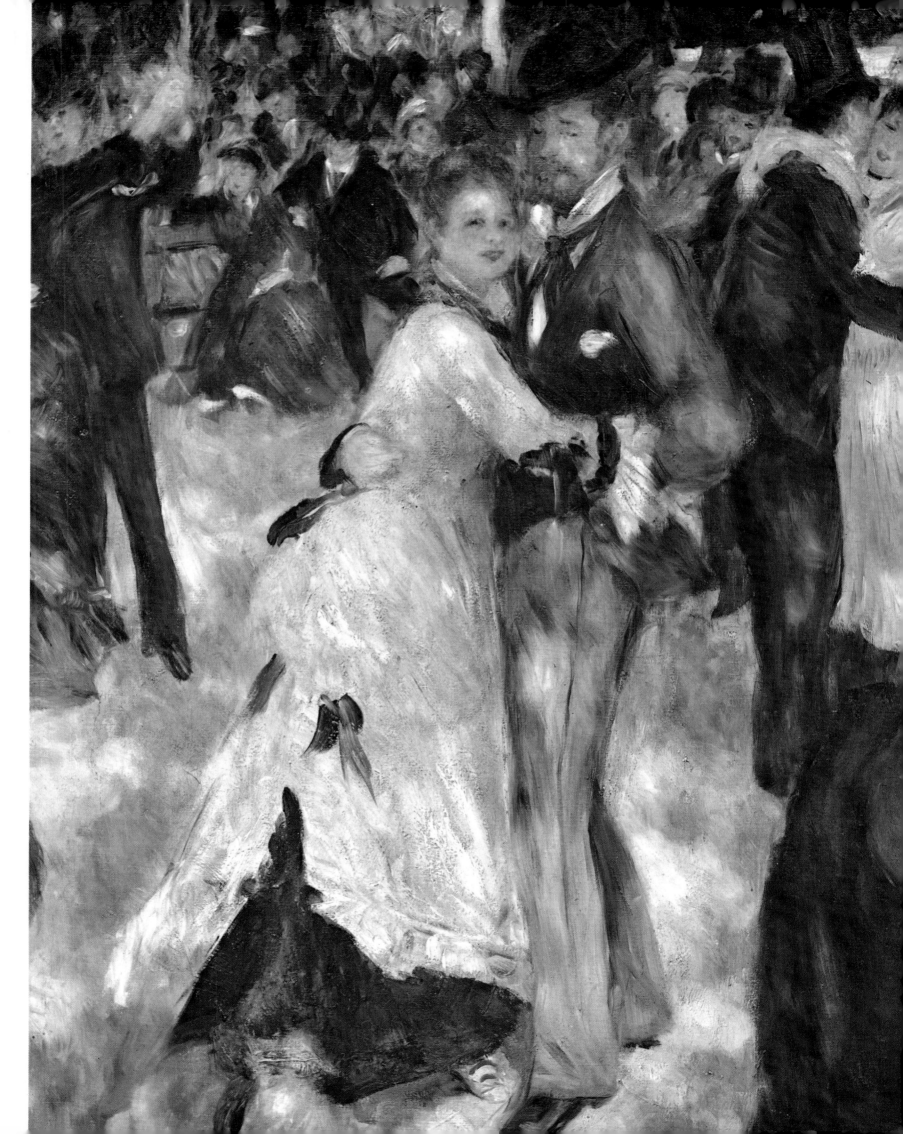

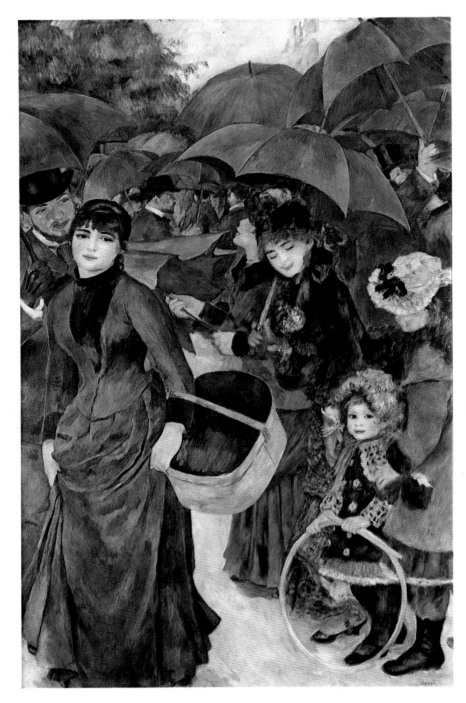

Renoir: *The Umbrellas*, 180 × 115cm (and detail opposite), 1881–6

public. In 1869 and 1870, it is true, the Salon jury had been elected by all those who had ever had paintings accepted at the Salon, and in 1870 all save Monet and Cézanne had had at least one painting accepted. But a powerful reaction to any kind of radicalism followed the excesses of the Commune and took a strong hold on the world of art in the early 1870s. The election of the jury was once again restricted to those who had won medals, and Courbet's works were denied exhibition on purely political grounds.

Courbet's 'Pavillon de Réalisme' at the Exhibition of 1855 and his and Monet's private exhibitions at the Exhibition of 1867 had already given Monet the idea of holding a separate show. In response to an article by Paul Alexis, published in May 1873, he relaunched the idea, and it was well received by his friends. Pissarro, as an anarchist, proposed a complicated and bureaucratic co-operative on the lines of the

Union of Bakers at Pontoise. This proposal Renoir, a believer in law, who nevertheless hated rules, defeated. Instead a company was formed whose founding members included Monet, Renoir, Sisley, Degas, Morisot and Pissarro. They decided to hold the exhibition in premises lent by the photographer, Nadar. Degas, keen to ensure that the group was not seen as one of unsuccessful, revolutionary, landscape painters, approached a number of older artists, while Pissarro incurred his displeasure by inviting Cézanne. Manet, who had enjoyed considerable success at the Salon of 1873 with his *Bon Bock*, and who believed that his dream of official recognition might soon be realized, refused to participate.

The exhibition opened on 15th April, 1874. Among Monet's works there was a view of Le Havre harbour in the morning mist, which he called *Impression, Sunrise*. Reviewers

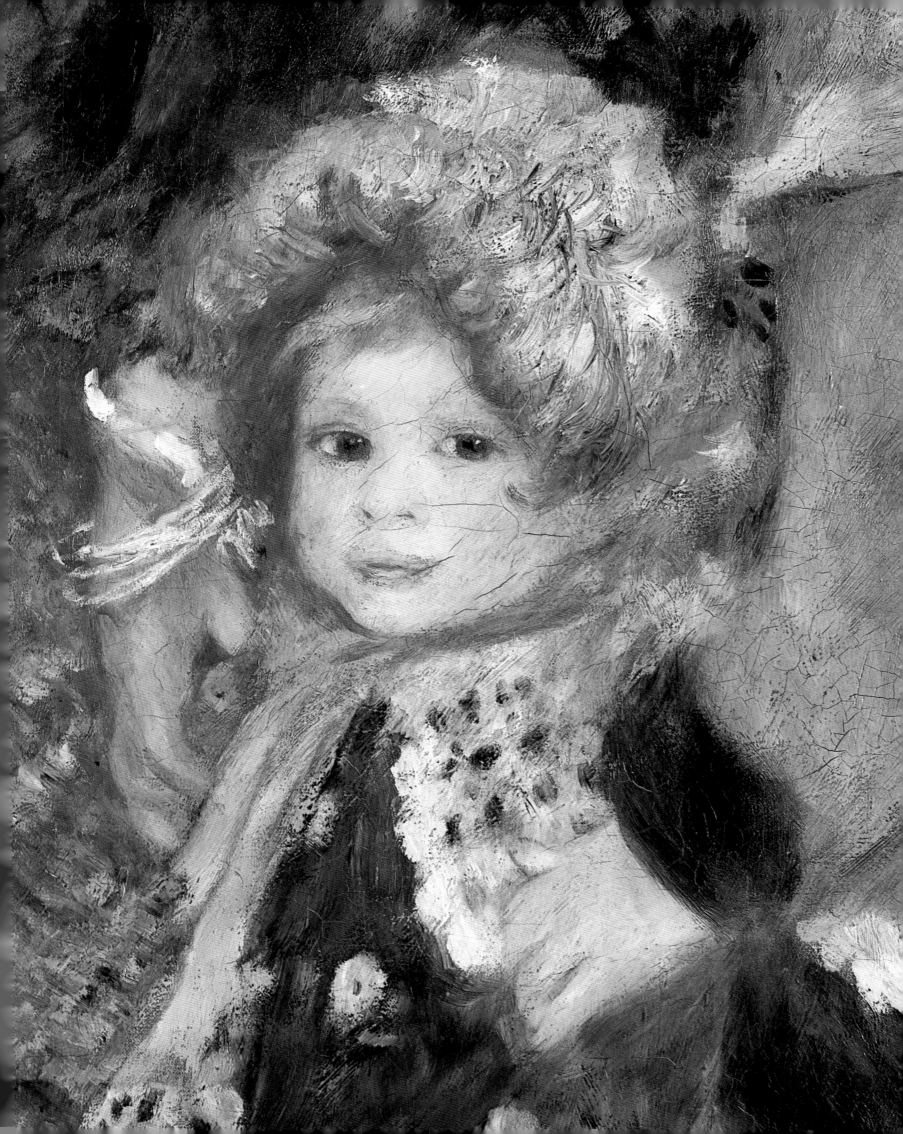

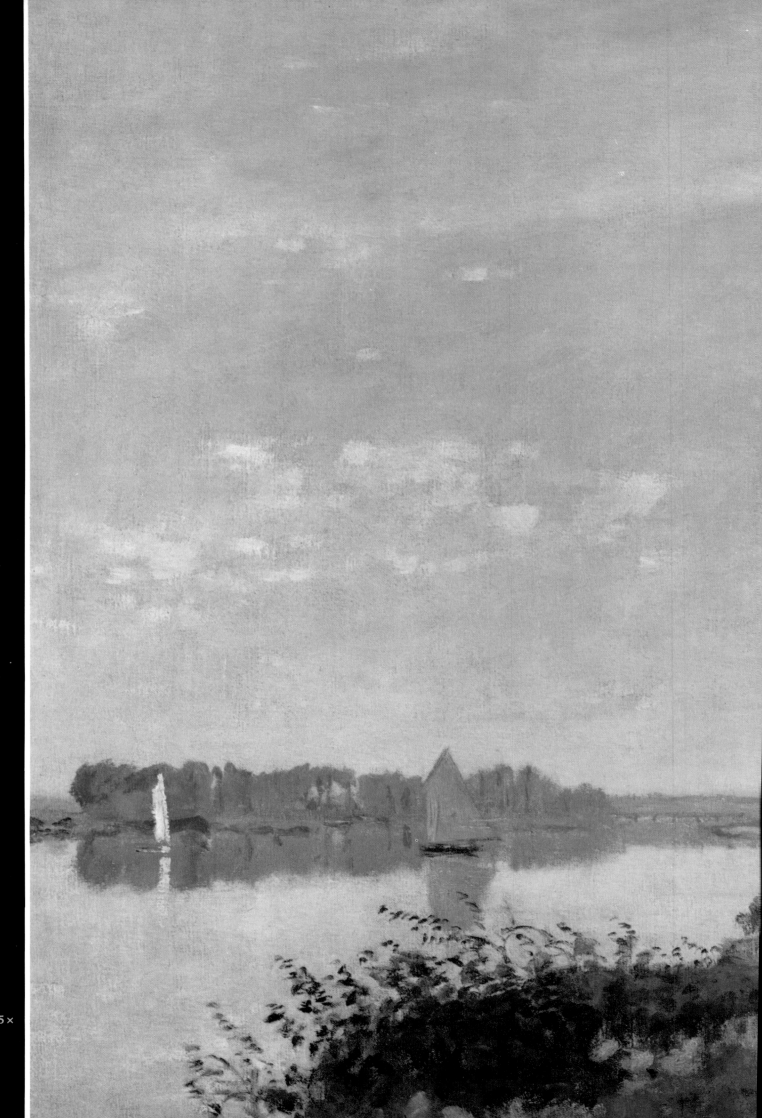

Monet: *The Promenade, Argenteuil*, 50·5 × 65cm, 1872

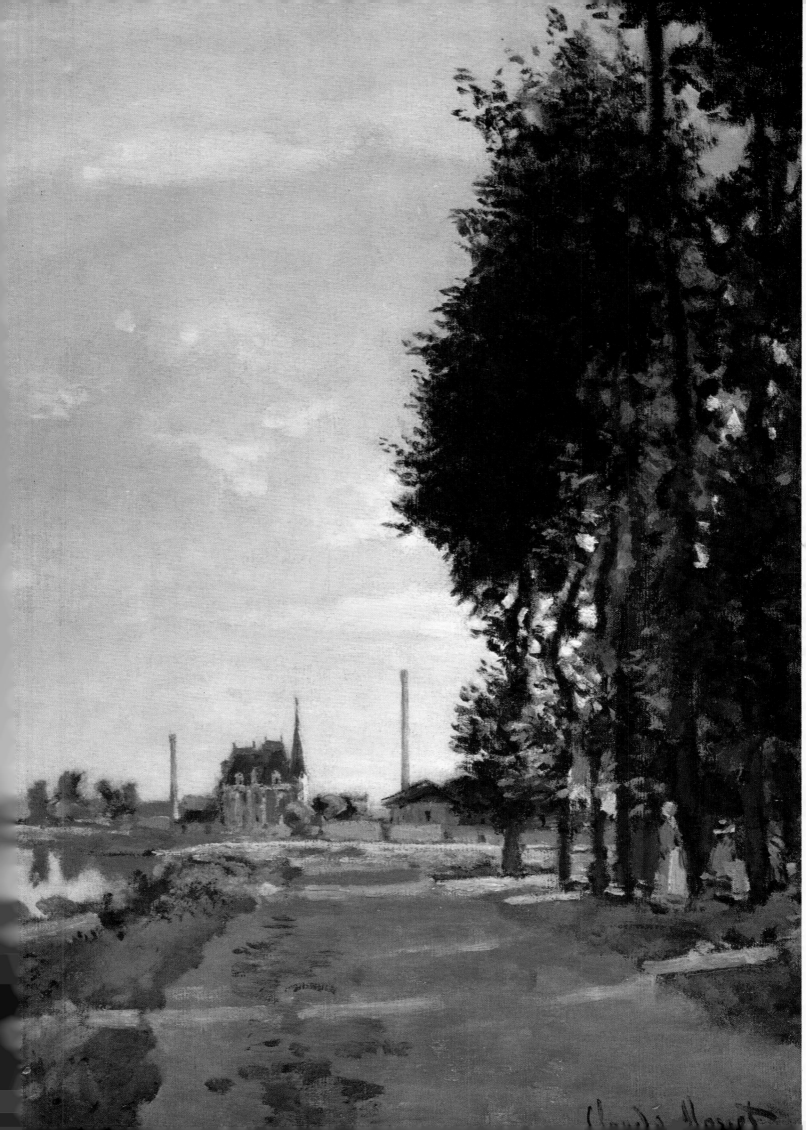

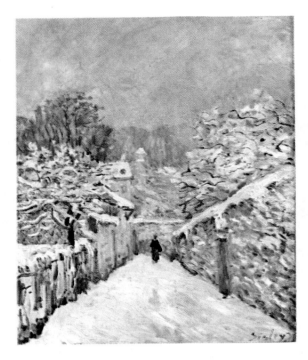

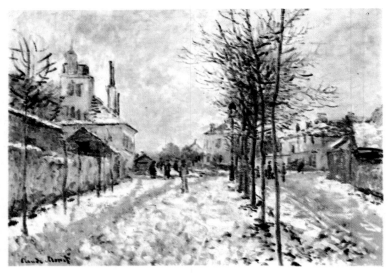

ABOVE **Monet**: *Snow Effect*, 60 × 81cm, 1875

LEFT **Sisley**: *Snow at Louveciennes*, 61 × 51cm, 1878

BELOW **Sisley**: *On the Banks of the Loing*, 54 × 65cm, 1896

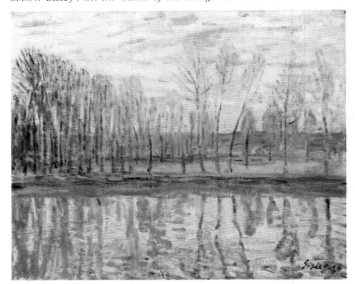

seized on this — Castagnary, for example, wrote: 'If one wants to characterize them with a single word that explains their efforts, one would have to create the new term of Impressionist. They are Impressionists in the sense that they render not a landscape, but the sensation produced by a landscape.' Other reviewers were, on the whole, less friendly and tended either to pass the exhibition over in silence or to mock the efforts of the artists represented in it.

Few people came to see the show, and fewer bought pictures. In short, it was not a financial success. The company had to be wound up, and the sale held to clear the debt was a disaster. Those members of the group without a private income and with a family, Monet and Pissarro in particular, were on occasion so desperately poor that they could not even afford to buy paint or canvas.

Yet somehow they continued to work. Monet as always pursued the most difficult and evanescent effects of light, by

Sisley: *The Flood at Port Marly*, 60 × 81cm, 1876

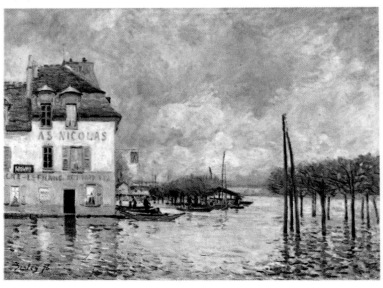

Sisley: *The Flood at Port Marly*
Sisley: *Snow at Louveciennes*
Sisley: *On the Banks of the Loing*

Some of Sisley's greatest works were painted at Port Marly doing the floods of 1872 and 1876. He has captured so well both the menace of the clouds and the brightness of the reflections in the water that here the two elements Impressionists revelled in most, sky and water, almost become one.

Twenty years later in *On the Banks of the Loing*, Sisley's style is freer and looser, but it is not radically different from his earlier works. He was, indeed, the most consistent of the Impressionists, for, having been freed from an exclusive dependence on Corot by Monet in the early 1870s, he was to remain true to the technique he adopted in that period to the end of his career.

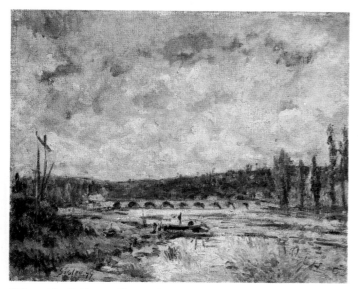

Sisley: *The Bridge at Sèvres,* 53 × 63cm

tankerous Degas and the others. Monet, Renoir, and Sisley only exhibited once after 1879, and by 1886 it was clear that the collective impulse which had led to the development of Impressionism was now a thing of the past.

It is difficult, even in retrospect, to decide whether these exhibitions, despite their historic importance in pioneering the idea of the anti-establishment group in art, were helpful to the careers of the participants. A number of the critics, many of them personal friends of the artists, had discussed the new movement with them at their evening gatherings at the Café Guerbois and were favourable. Among these were Edmond Duranty, who published *La Nouvelle Peinture,* the first work devoted to Impressionism, at the time of their second exhibition, and Georges Rivière, who published a journal *L'Impressionniste* during their third one. Another critic was Émile Zola, the great realist writer, who had been a close friend of Cézanne in his youth. On the other hand, the

the river, in the fields, or in the steam rising from the railway engines, in 1877, in the Gare St-Lazare. Renoir, besides his landscapes, found happy inspiration in recording the pleasures of all ranks of Parisian society, as in *Moulin de la Galette* and *The Swing,* and Pissarro applied himself to the effect of the changing seasons of the countryside around Pontoise in paintings such as *Village near Pontoise, Harvest at Montfoucault, Kitchen Garden and Trees in Blossom,* and *The Red Roofs.* Morisot produced intimate yet freely handled scenes of family life, and Sisley was inspired to paint some of the most delicate and poetic of Impressionist landscapes, such as *The Flood at Port Marly* and *Snow at Louveciennes.*

Above all they continued to exhibit, in 1876 at the gallery of the only dealer in their work, Paul Durand-Ruel, and in 1877, emphasized their anti-establishment stance under the title, *Exposition des Impressionnistes.* Further exhibitions in 1879, 1881, 1882, and 1886 even had a certain financial success, yet gradually the members of the group drifted apart. Pissarro and Morisot, though consistently loyal, found it impossible to keep the peace between an increasingly can-

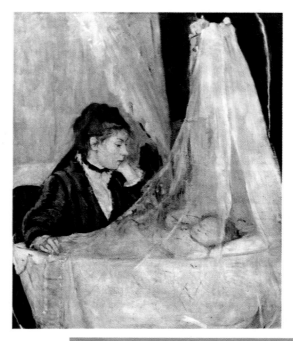

Morisot: *The Cradle,* 56 × 46cm, 1873

Morisot: *Field of Corn,* 47 × 69cm, 1875

Morisot: *The Cradle*
Morisot: *Field of Corn*
Morisot: *In the Garden* (pages 34-5)

Berthe Morisot was introduced to Corot in 1861, and painted with him in the open air. The second most important influence on her art was Manet, whom she met in 1868. She posed for him a number of times, and in 1874 she married his brother Eugène. Against Manet's advice she exhibited at the first Impressionist exhibition and from then on showed with them and not at the Salon. Her work introduces a touch of sentiment and a picture of upper bourgeois family life into Impressionism.

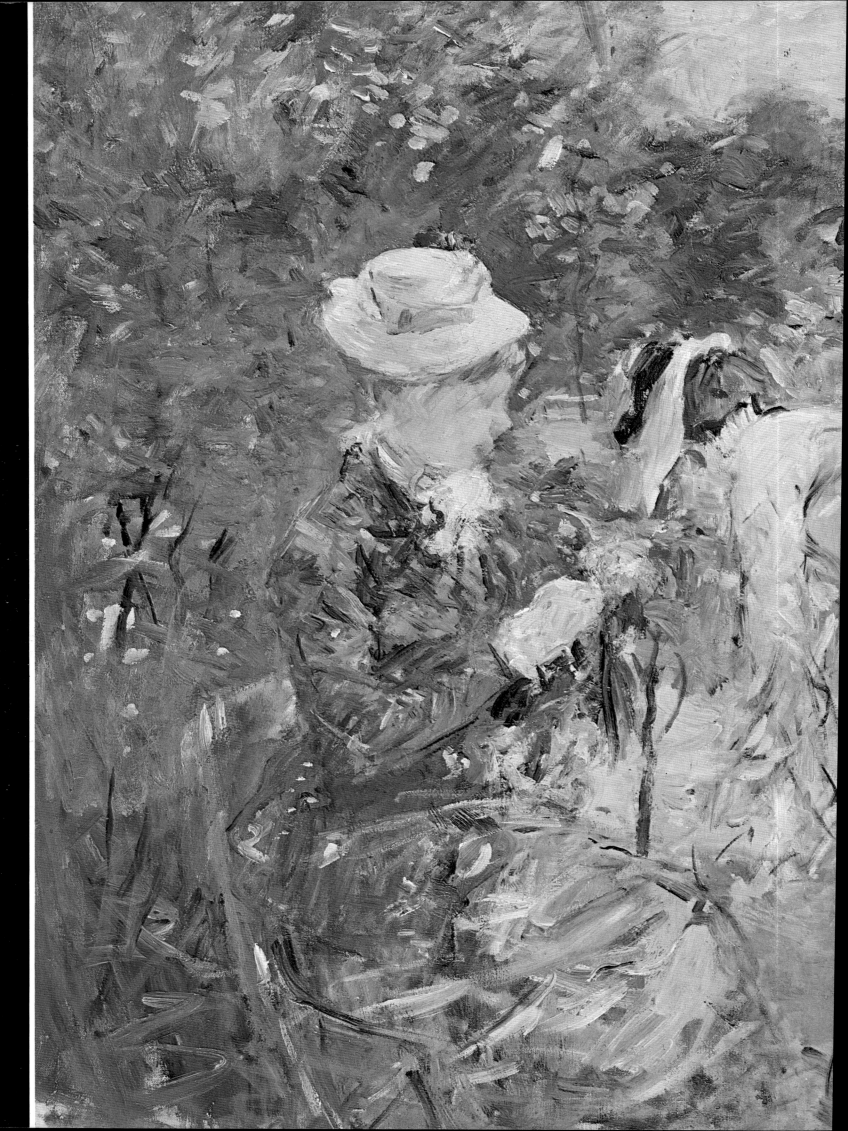

Morisot: *In the Garden,* 61 × 75cm

Impressionists provoked continuing violent attacks from a larger number of hostile critics and laughter from the public. Albert Wolff, one of the most influential of reviewers, compared their work to that of a monkey with a box of paints. His review of the second Impressionist exhibition went further and described them as 'five or six lunatics . . . self-styled painters' who 'take canvases, colour and brushes' and

Pissarro: *The Harvest at Montfoucault*
Pissarro: *Kitchen Garden and Trees in Blossom*
Pissarro: *The Red Roofs*

Pissarro was not attracted to painting river scenes in the same way as Monet, Sisley and Renoir. He was closer in spirit to the earth and its cultivation, and believed in the dignity of work on the land. This feeling is evident in *Harvest at Montfoucault*, which was painted during a holiday he spent with Ludovic Piette. In this painting as in *The Red Roofs* Pissarro's interest in construction is apparent and this too marked him out from the other Impressionists. It may partly explain the instinctive sympathy that Cézanne felt for his work when he joined Pissarro at Pontoise in 1872.

ABOVE **Pissarro:** *Kitchen Garden and Trees in Blossom*, 65 × 82cm, 1877

LEFT, ABOVE **Pissarro:** *The Harvest at Montfoucault*, 65 × 93cm, 1876

LEFT, BELOW **Pissarro:** *Le Pont Neuf*, 55 × 46cm

Pissarro: *Landscape at Pontoise*, 65 × 51cm

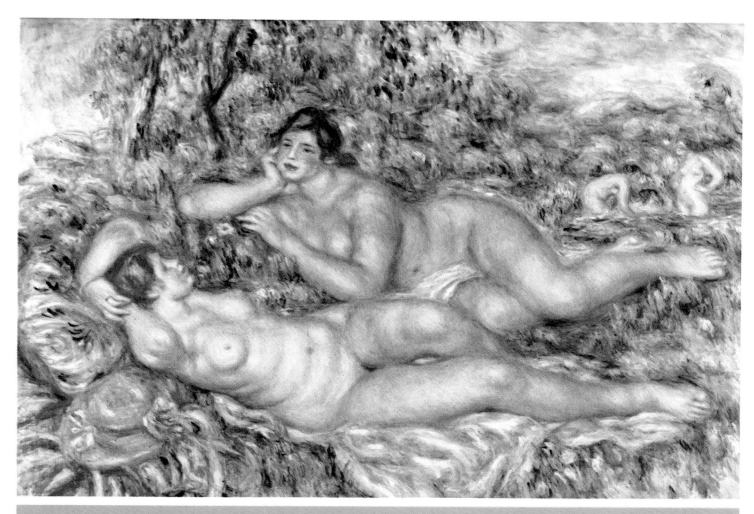

Renoir: *The Bathers,* 110 × 160cm, 1918–19

Renoir: *The Bathers*
Pissarro: *Woman in an Orchard*

In the early 1880s Impressionism, or rather some Impressionist painters, suffered a crisis; it seemed as though their sense of purpose had deserted them. Pissarro as one of the leading theorists of the group was interested in the optical theories of Chevreul and the work of Seurat. He began to paint in the Divisionist style and in the last Impressionist exhibition showed paintings in that style next to Seurat's work.

The Bathers was the last large canvas that Renoir painted. He had come through his 'sour' period to develop a form of 'classicism' through which he sought to rejoin what he saw as the mainstream of European art. Yet he remained a supremely natural painter delighting in the interaction of bright colours. 'I have no rules and no methods,' he said, 'and I want to be sonorous, to sound like a bell, if it doesn't turn out that way, I put more reds or other colours until I get it.' He never lost his joy in painting and, though crippled, was able to work right up to his death in December 1919.

Pissarro: *The Red Roofs,* 55 × 67cm, 1877

Pissarro: *Woman in an Orchard.* 54 × 65cm, 1887

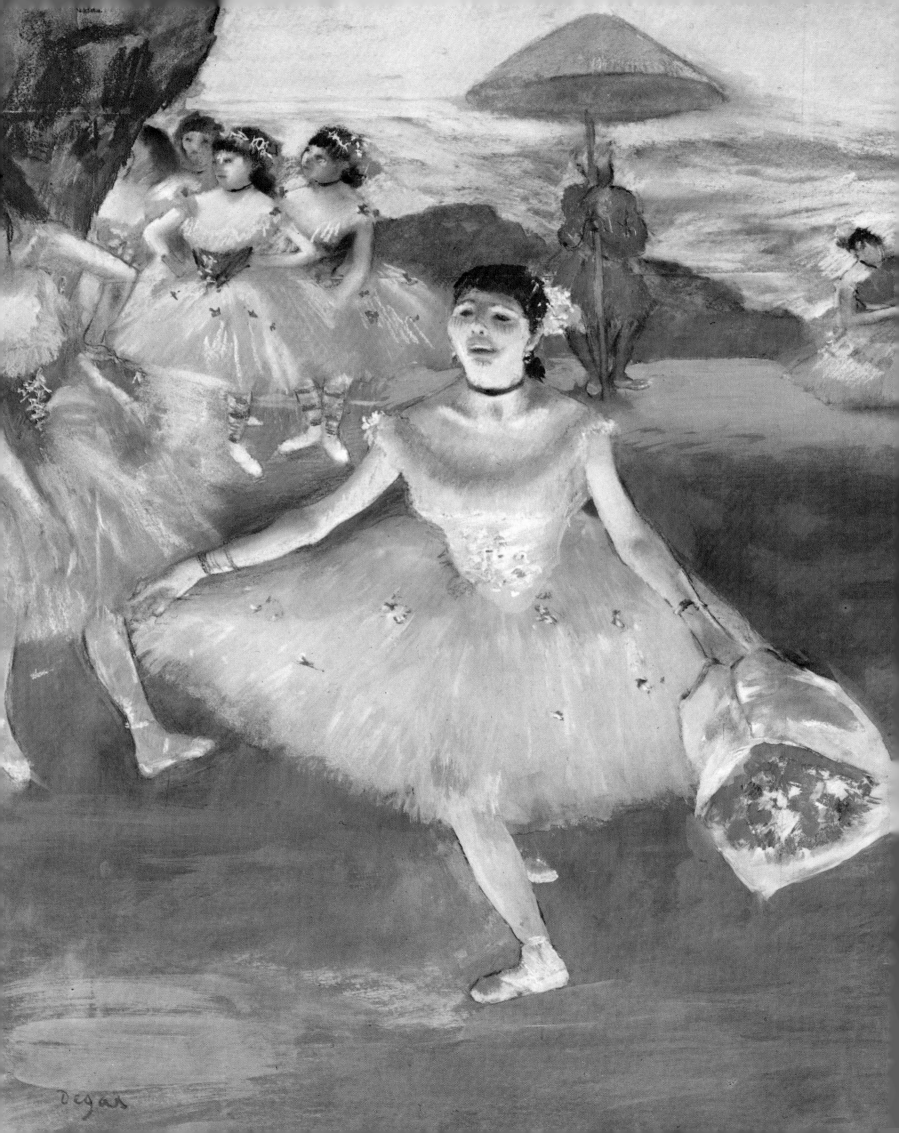

ABOVE **Degas:**
*Four Dancers
on Stage,* 73 ×
92cm, c.1892

RIGHT **Degas:**
*The Ballet
School at the
Opera,* 65 ×
50cm, c.1890

Degas: *Dancer with a Bouquet Bowing on Stage*
Degas: *Dancers in the Wings* (page 40)
Degas: *Four Dancers on Stage*
Degas: *Three Russian Dancers* (page 40)

Degas began to introduce subjects from the opera and ballet
into his work from 1872 onwards (he had painted the
Orchestra of the Opera as early as 1869 for his friend, the
cellist, Dihau). He was fascinated with the contrast of light and
shade in the stage scenes and with the effect that the
discipline of ballet produced on the bodies of young girls. The
works illustrated here show how he became more interested in
dense packed groups of figures; a supreme example of his
experiments on this theme is the *Three Russian Dancers*. He
made a large number of preparatory studies for this work, and
in this version he has achieved the effect of a solid yet dynamic
group of figures.

LEFT **Degas:**
*Dancer with a
Bouquet
Bowing on
Stage,*
72 × 78cm,
c.1876–7

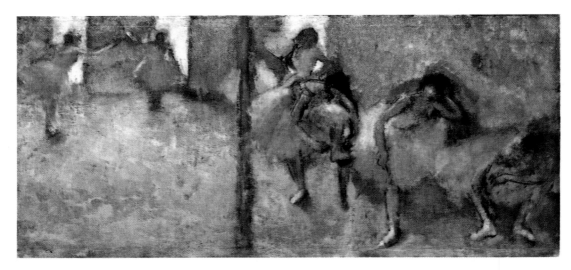

Degas: *Dancers in the Wings,* 65 × 50cm, c.1890

'throw on a few tones at random'. Others like Émile Porcheron were no kinder. 'What is an Impressionist?' he asked, and went on 'For us an Impressionist is a man who, without knowing why, feels the need to consecrate himself to the cult of the palette and who, having neither the talent nor the training necessary to achieve a worthwhile result, is content to give the public canvases which have scarcely more value than the frames which surround them.'

Such authoritative statements about values were of crucial importance in an age as obsessed as our own with the idea of painting as an investment. Durand-Ruel, the only major dealer sympathetic to the Impressionists, had met Monet through Daubigny during the Franco-Prussian war. Through Monet he came to know Pissarro, Renoir, Degas and Sisley. He bought their work and tried to push it in London and Paris. He acted as their 'expert' at the sale in 1875, and let them use his galleries in 1876. Yet the financial crises that he suffered as a result of the depression that hit France during 1874–80, and again in 1884, made him periodically unable to help them. Further, his rival dealers, jealous of his exclusive links with so many painters of the modern school, fostered the view of critics like Porcheron, that Impressionist works were a bad investment, fundamentally worthless and likely to remain so.

Their exhibitions certainly made the Impressionists a reputation of a kind, and to begin with Pissarro could say bravely, 'Our exhibition . . . is a success. The critics are devouring us and accuse us of not studying.' But though

Degas: *Three Russian Dancers,* 62 × 67cm, c.1895

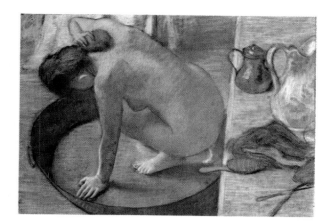

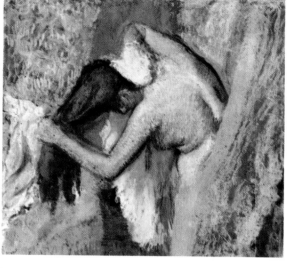

LEFT **Degas**: *The Tub*, 60 × 83cm, 1886

RIGHT **Degas**: *Woman at her Toilet*, 75 × 73cm, c.1903

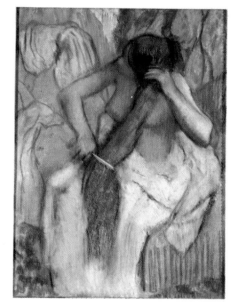

Degas: *Woman Brushing her Hair*, 82 × 57cm, 1886

they had been able to build up a small group of collectors and friends like Victor Choquet, Gustave Caillebotte, and Dr Gachet, it came to seem to Monet and Renoir that they could only overcome public prejudice by breaking with the group, exhibiting separately, or even through the Salon, and selling their works through other dealers like Georges Petit.

Why the work of the Impressionists should have encountered such an impenetrable barrier of hostility is difficult for us, now, to understand. Armand Silvestre after all, in a review of their first exhibition, had noted that in their paintings 'everything is joyousness, clarity, spring festivals, golden evenings or blooming apple trees. Their canvases . . . seem to open windows on a gay countryside . . . on a cheerful and charming outdoor life' — exactly the qualities that make their art so popular today. Of course their tech-

Degas: *Woman at her Toilet*, 96 × 110cm, c.1894

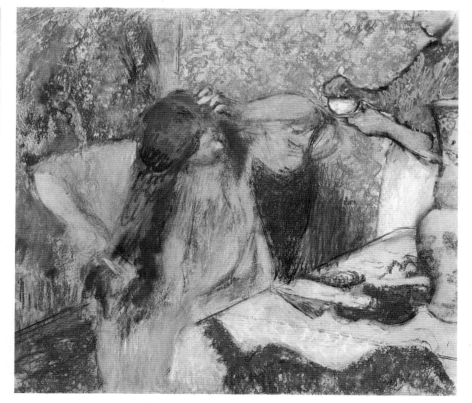

Degas: *The Tub*
Degas: *Woman Brushing her Hair*
Degas: *Woman at her Toilet*
Degas: *Woman at her Toilet*

At the eighth and last Impressionist exhibition in 1886, Degas showed a series of pastels, called in a very matter of fact way 'Series of nudes, women bathing, washing, drying themselves, combing or having their hair combed'. He developed this theme from then until his death. He had been trained by pupils of Ingres and their influence led him to develop his draughtsmanship, which is at its most masterly in dealing with the female nude. He presents his figures in a strictly impersonal manner, seeking out positions of the body which were bold and unconventional. To paint these he fitted out his studio with bath tubs and basins and, instead of posing his models in the traditional way, watched as they washed and dried themselves or combed each other's hair. After they had gone he painted from memory the more remarkable poses that they had adopted in the course of their toilet. These studies mark a new naturalism in the treatment of the nude; the women are portrayed not as the objects of male desire, aware of the presence of a male observer, but as human animals, going about their business as if unaware that they are being observed.

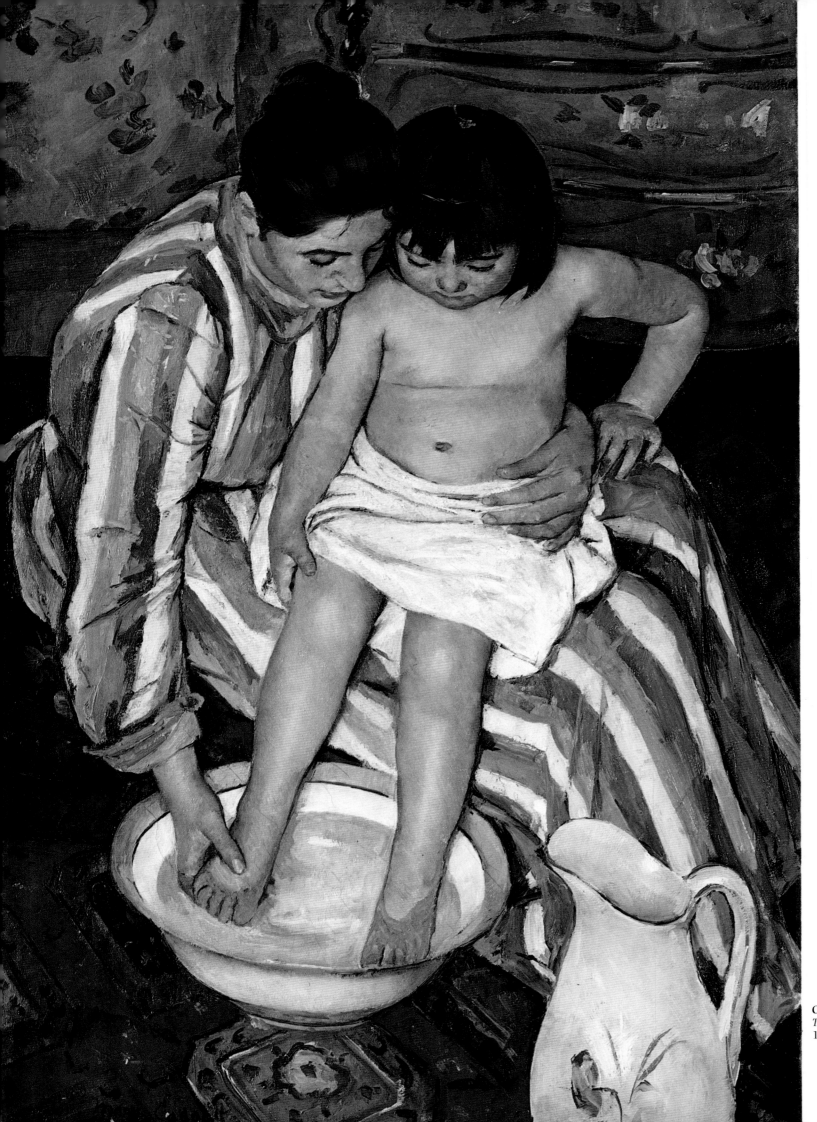

Cassatt:
The Toilet.
100 × 66cm

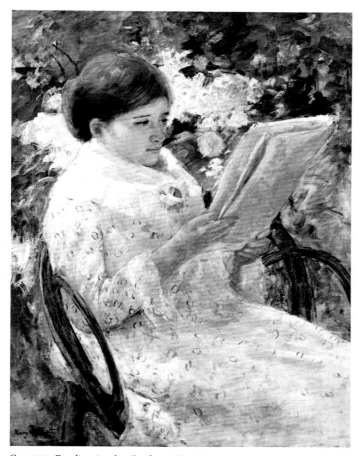

Cassatt: *Reading in the Garden.* 89 × 65cm

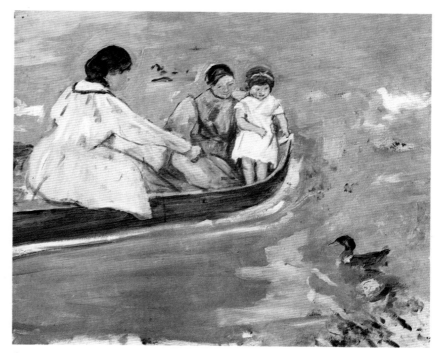

Cassatt: *In the Boat.* 60 × 73cm

nique and subject matter were novel. Comparing their canvases to those of official painters, one can see that they might seem unduly bright and quite unfinished. Yet it is still difficult to understand the real anger, and even hatred, that could lead a painter like Gérôme as late as 1893 to describe Caillebotte's bequest of Impressionist paintings to the state as 'filth'.

The clue lies in the fact that the reception of their work was marginally friendlier under the authoritarian regime of Napoleon III than under the republic which overthrew it. In 1870 and 1871 not only was France defeated by the Prussians, and the Empire overthrown, but Paris was ravaged and public monuments were destroyed by her own people, and some 20,000 insurgents were killed by the forces of reaction. As a result the endemic divisions and resultant hatred and fear, present in French society throughout the

nineteenth century, were present in a particularly acute form during the 1870s.

Fear of change reached such a point in the art world that the jury of the 1878 Universal Exhibition excluded not only the Impressionists but even Delacroix, Millet and Rousseau. In this situation it is not surprising that a group that set out to overturn the accepted canons of taste, mocked the estab-

Cassatt: *Mother and Child.* 71 × 58cm

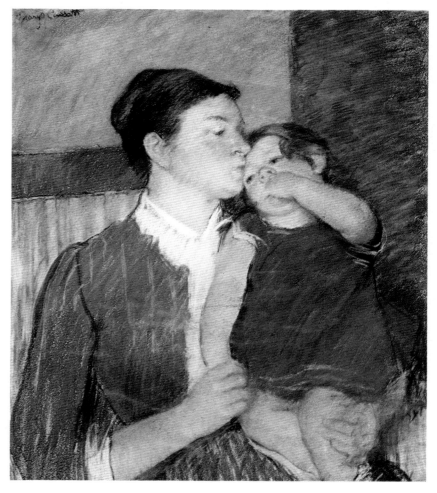

Cassatt: *Mother and Child*
Cassatt: *In the Boat*

Mary Cassatt was the daughter of a rich Pittsburgh banker. She worked in France from 1868, and in 1874 exhibited at the Salon. Degas became one of her supporters and she was very much influenced by his style. The study of line was important in her art, which she developed through the influence of Degas and by studying Japanese prints. She exhibited at four of the last five Impressionist exhibitions and did her best to convince her family and American friends that the works of the Impressionists were worth buying.

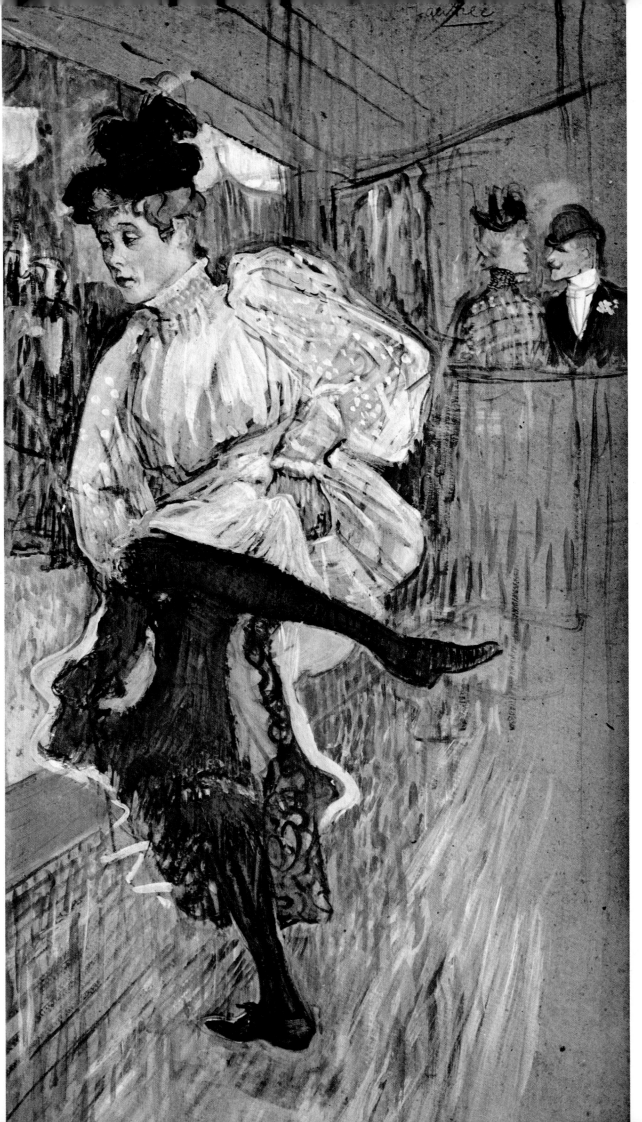

Toulouse-Lautrec: *Jane Avril Dancing*, 86 × 45cm, c.1892

RIGHT **Toulouse-Lautrec**: *At the Funamula Circus*
47 × 32cm, 1899

BELOW **Toulouse-Lautrec**: *The Clown Cha-U-Kao*,
64 × 49cm, 1895

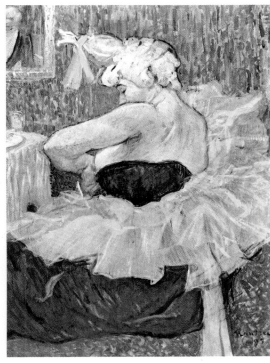

lishment, disdainfully opened a separate exhibition before the Salon, and from 1877 forbade its members to show there, was classed as revolutionary. The *Universal Monitor*, for example, on the grounds of a favourable review in a radical paper, noted that 'the intransigents of art join hands with the intransigents of politics', adding that such an alliance was only to be expected. Yet, though the majority of the group, including Manet and Monet, were left-wing, only Pissarro was positively committed to revolution, and, in the end, only Pissarro, out of political conviction, and Degas, out of pride and disdain, remained committed to challenging the system. Monet and Renoir increasingly felt the need to dissociate themselves from an anti-establishment stance so that, presenting no threat to society, they could at last receive recognition. Renoir indeed actually wrote to Durand-Ruel, before the last Impressionist exhibition (1882) in

which he participated, to say that he did not wish to be associated with Pissarro on account of his political ideas, and added that he would continue to exhibit at the Salon to 'dispel the revolutionary taint, which frightens me'.

There was however another and even more important reason for the break-up of the Impressionist group. In the 1870s they developed and exploited their solution to the problem that had led them to Impressionism. Having done so, they began to feel the force of Castagnary's criticism of their first exhibition: 'Before many years,' he had written, 'the artists grouped at the Boulevard des Capucines today will be divided. The strong . . . will have recognized that if there are some subjects suitable for an "impression" . . . there are others . . . which are not.' He implied that the stronger artists, having 'perfected their drawing, will abandon impressionism'. By 1883 Renoir, as if haunted by this

Toulouse-Lautrec was trained at the studio of Fernand Cormon, an academic painter of pictures about pre-historic life. His fellow pupils included Émile Bernard and Vincent van Gogh. He became friends with both of them and did a portrait of van Gogh sitting at a café. After an Impressionist phase he developed a linear style closer to Degas, and concentrated on scenes of life in cafés and cabarets, like the Cabaret of the Assassins (later to become The Agile Rabbit). Toulouse-Lautrec's scenes of nightlife show a much greater personal involvement with the characters than Degas's more impersonal style. In *At the Moulin Rouge* Lautrec himself is portrayed. Among the performers with whom he became intimate were Jane Avril and La Goulue, two very different characters. Avril's melancholic countenance and graceful figure were often portrayed as was the very vulgar and lively La Goulue. *The Moorish Dance* was painted for her booth at the Foire du Trône when her career had gone into eclipse. Cha-U-Kao was also a favourite subject of Lautrec's. The portrait of her is particularly original both in pose and in the brilliant yellow of the ruff, which curves around her body.

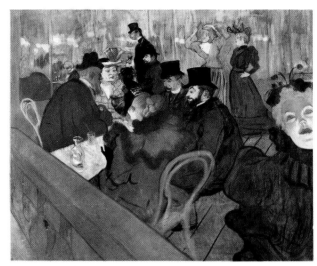

Toulouse-Lautrec: *At the Moulin Rouge,* 123 × 140cm, 1892

prediction, felt that he no longer knew how to paint or draw, turned away from Impressionism and began to concentrate on line rather than colour. Pissarro became worried by what he considered to be his 'unpolished and rough execution', and Monet wrote to Durand-Ruel: 'I have more and more trouble in satisfying myself and have come to a point of wondering whether what I do is neither better nor worse than before, but the fact is simply that I have more difficulty now in doing what I formerly did with ease.'

Each of these painters was to find his own way out of this impasse. Sisley alone of the original band continued to paint in a purely Impressionist style right up to his death in 1899. Conscious, perhaps, that he would never be able to surpass the pure joy of his early land- and cloudscapes and the

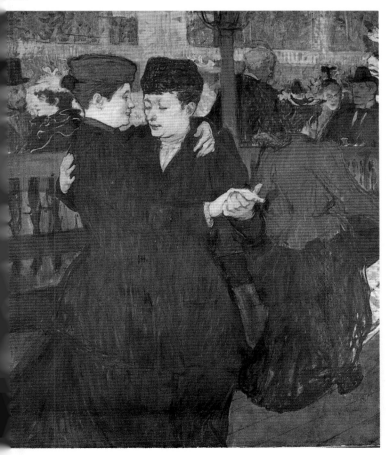

Toulouse-Lautrec: *Women Dancing at the Moulin Rouge,* 93 × 80cm, 1892

Toulouse-Lautrec: *The Moorish Dance,* 285 × 380cm, 1895

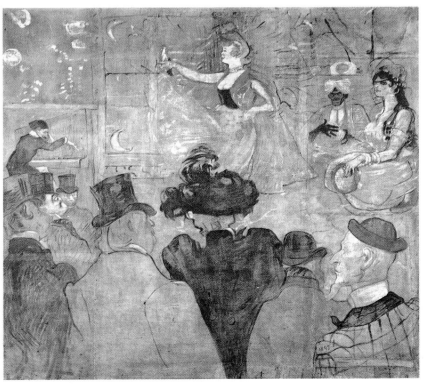

OPPOSITE **Toulouse-Lautrec:** *At the Moulin Rouge* (detail)

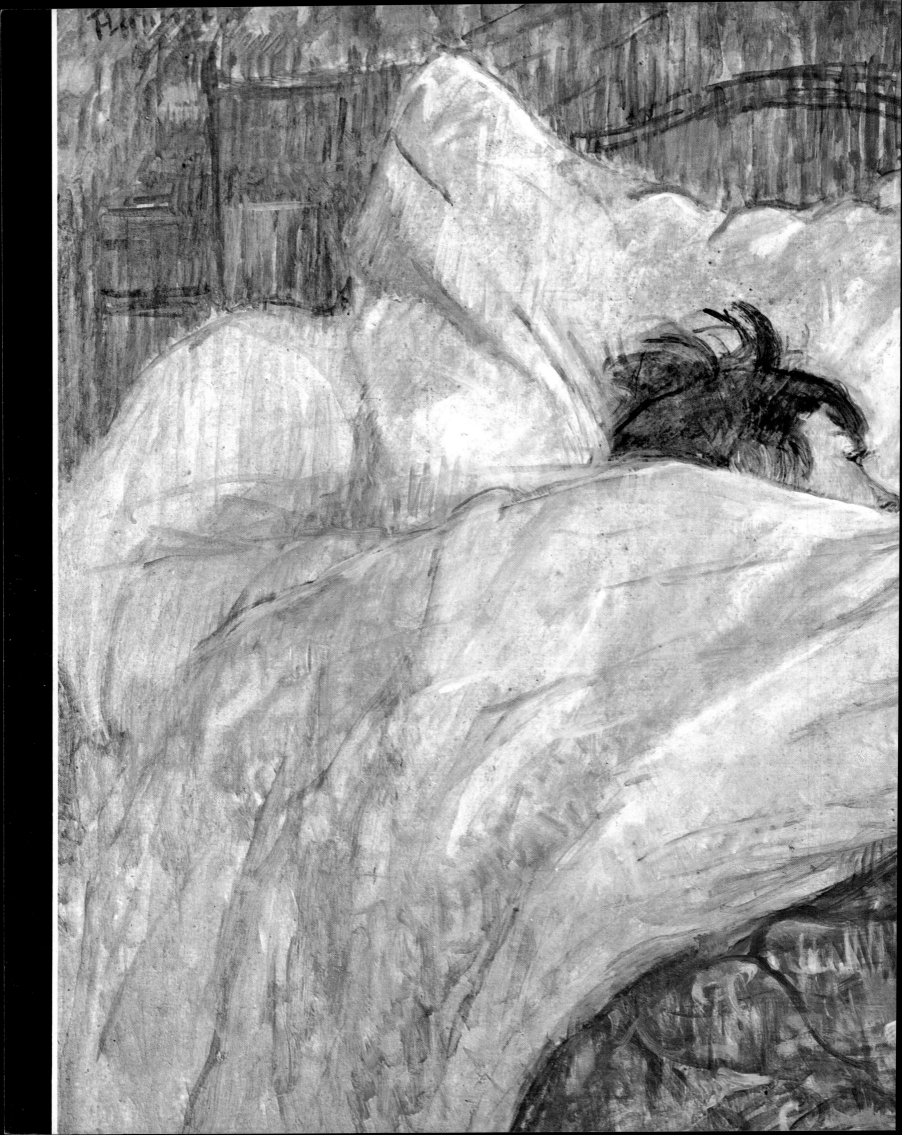

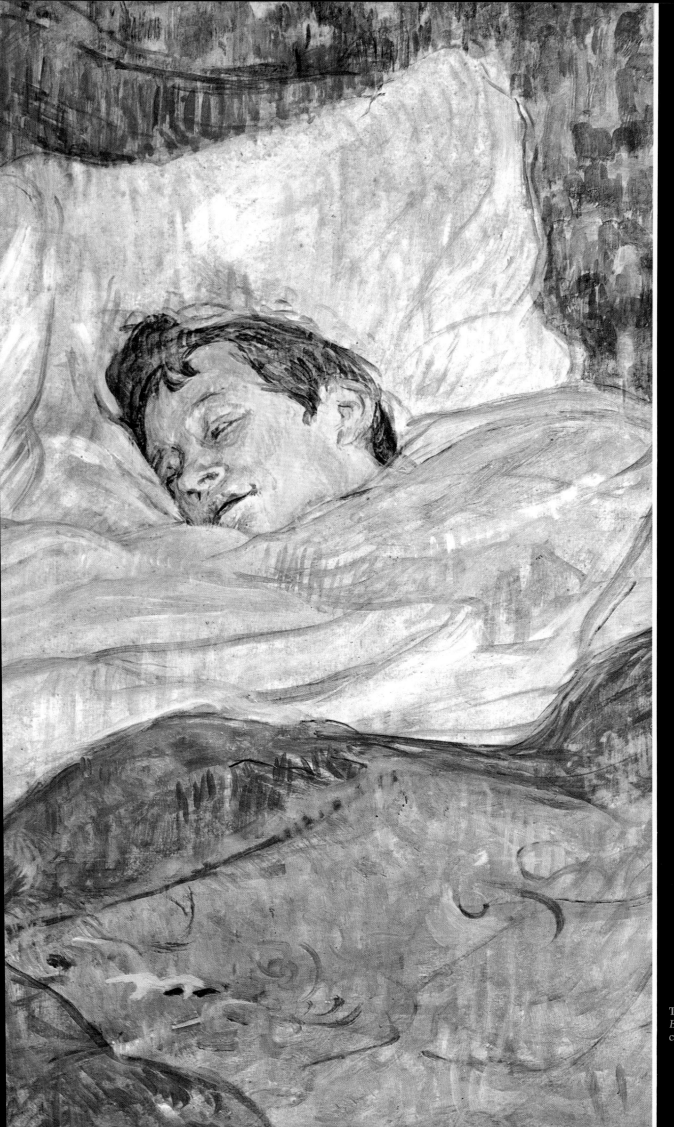

Toulouse-Lautrec: *The Bed*, 53 × 70cm, c.1892–5

Toulouse-Lautrec: *The Couch*, 60 × 80cm, 1893

Toulouse-Lautrec: *The Bed*
Toulouse-Lautrec: *The Couch*
Toulouse-Lautrec: *The Women*

Among Toulouse-Lautrec's paintings of Parisian nightlife are a series of studies done in the *maisons closes* or brothels. *The Couch* shows the 'girls' awaiting customers in a 'house' in the rue des Moulins. He often chose for his subjects the lesbian love affairs among the prostitutes. *The Bed* is one of a number depicting the same two women. Lautrec makes no judgement of the morality of prostitution in his painting, but merely records the common-place events of the daily life of those involved in it.

Toulouse-Lautrec: *The Women*, 60 × 80cm, 1895

OPPOSITE **Toulouse-Lautrec:** *The Women* (detail)

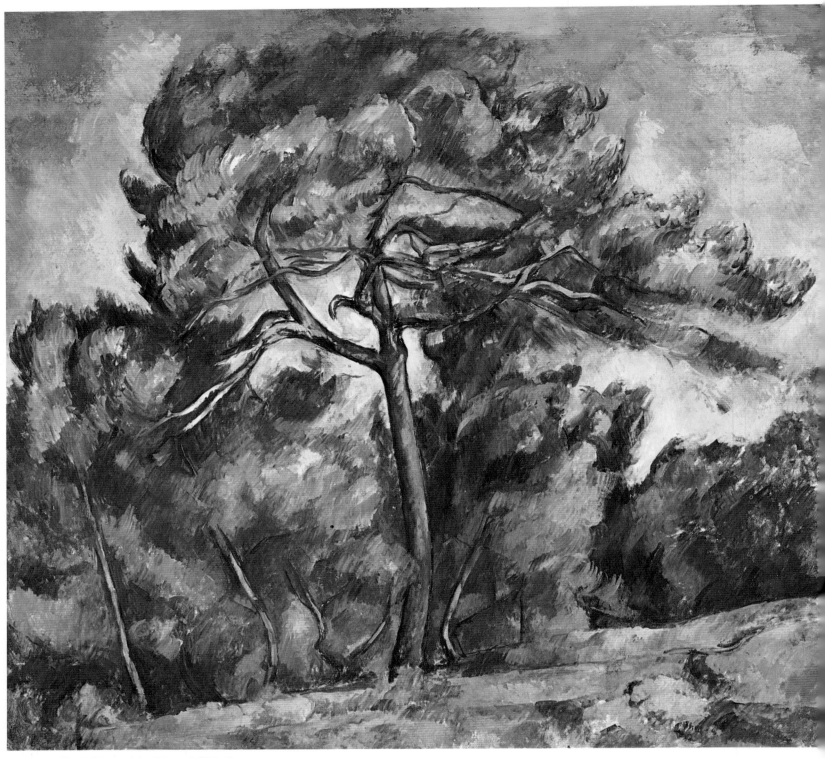

Cézanne: *The Tall Pine*, 84 × 92cm, 1892–5

poetic serenity of his studies of rivers and floods, such as *Ile de Grande-Jatte* and *The Flood at Port Marly*, he grew increasingly bitter in his isolated and poverty-stricken old age.

Friends and Contemporaries

If the term Impressionist is used strictly, to refer only to the originators and users of a specific technique for transcribing the effects of sunlight on objects in the open air, then only a small proportion of the exhibitors at the Impressionist exhibitions can be so described. Yet, to contemporaries and to the painters themselves, it had a wider signification. Manet, though he used Impressionist techniques only briefly, and never exhibited with the group, was often referred to as the leader of the movement. Degas was not only uninterested by, but positively opposed to, painting in the open air or even directly from the model. He admired Ingres, considered line of supreme importance and colour a dangerous distraction. Yet, though the mirror image of an Impressionist in his opinions, he was an absolutely central figure in the group.

Edouard De Gas (who later signed himself Degas) was born in Paris in 1834, the son of a banker from a good family who collected the work of Ingres. Until 1862, when he met Manet, who was like himself something of a smart young man about town, Degas seemed set on a conventional career as a history painter. Like Manet, however, he became interested in Baudelaire's idea of the 'painter of modern life'. He found a description of this desired but imaginary creature

52

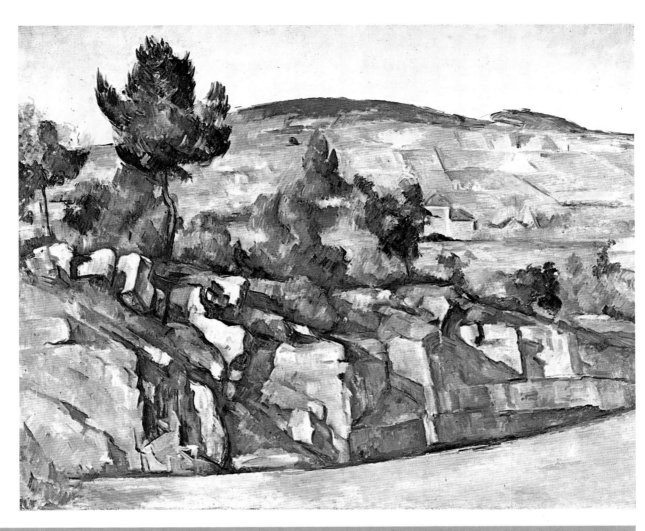

RIGHT **Cézanne**: *Rocky Landscape at Aix*, 64 × 79cm, 1886–90

BELOW, LEFT **Cézanne**: *The House of the Hanged Man*, 55 × 66cm, 1873

BELOW, RIGHT **Cézanne**: *L'Estaque*, 73 × 91cm, 1882–5

Cézanne: *The House of the Hanged Man*
Cézanne: *L'Estaque*
Cézanne: *Rocky Landscape at Aix*
Cézanne: *The Tall Pine*

Cézanne met the Impressionist circle at the Café Guerbois. Reflected in his early work are an admiration for Delacroix and love of Venetian colour. In 1872 he joined Pissarro at Pontoise and under his influence abandoned dark earthy colours, his palette becoming brighter in the Impressionist manner. In *The House of the Hanged Man* the influence of Pissarro can be detected in his use of dabs of colour on the roof to the right, and like Pissarro he displays a much more developed interest in the structure of the scene than Monet or Renoir would have done with the same scene. This painting was exhibited at the first Impressionist show and was ridiculed by the critics.

During the Franco-Prussian war he had moved to L'Estaque, an industrial suburb of Marseilles, and from then on he spent most of his life in the south of France. By 1880 he had abandoned straightforward Impressionism. He sought to attain stability and convey his own sensations when confronted with a scene rather than the fleeting impression of it.

53

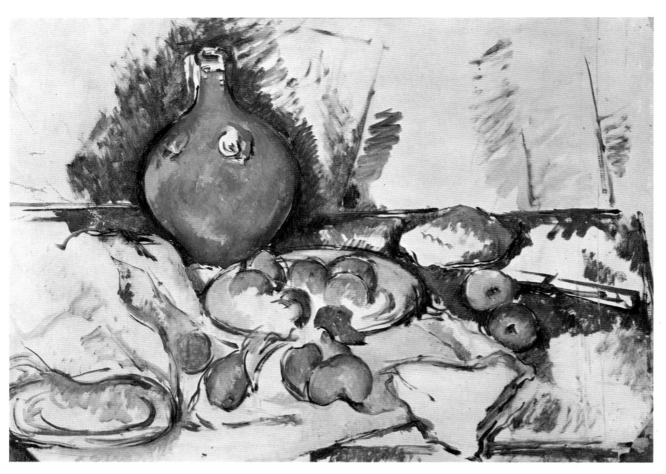

Cézanne: *Still Life with Water Jug*, 53 × 71cm, c.1892–3

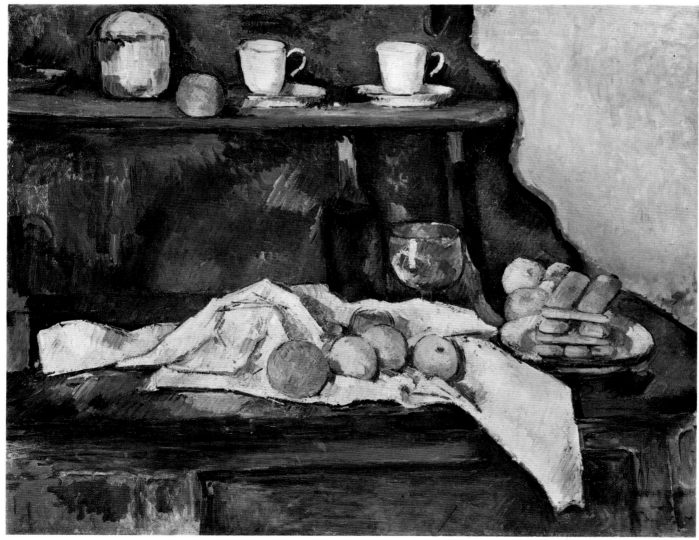

Cézanne: *The Dresser*, 65 × 81cm, 1873–7

54

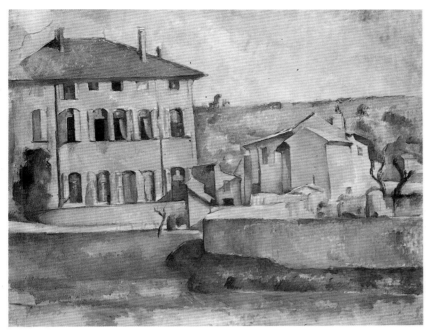

Cézanne: *House at Aix*, 60 × 73cm, 1885–7

Cézanne: *La Montagne Sainte-Victoire*, 64 × 72cm, 1904–6

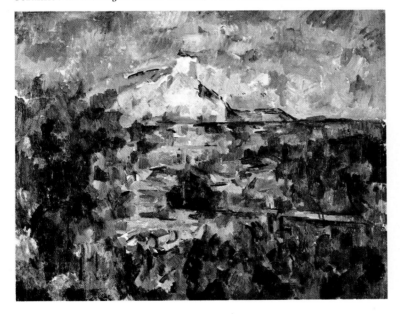

Braque: *The Mandolin Player*, 151 × 78cm

Cézanne: *La Montagne Sainte-Victoire*
Braque: *The Mandolin Player*

The memorial exhibition of Cézanne's oils in 1906, an exhibition of his watercolours and the publication of his letters to Bernard in the autumn of the following year had a profound effect on Braque. In his letters Cézanne advised Bernard to 'treat nature by the sphere, the cylinder and the cone'. Braque took this to mean a search for the geometrical forms behind natural appearances. Braque and Picasso carried these researches further, applying them to figures and still-life studies as well as to landscape. Unlike Cézanne, Braque severely restricted the colours in his palette. For him the structures behind form were all-important and colour a secondary concern.

in a novel by the Goncourt Brothers, *Manette Salomon*, which was published in 1867. 'All ages carry within themselves a Beauty of some kind or other,' they wrote. 'There must be found a line that would precisely render life, embrace from close at hand the individual, the particular, a living human, inward line.' In his notebooks Degas outlined plans to explore the possibilities of contemporary life, such as studying musicians with their instruments, cigarette smoke, smoke from steam engines, the naked legs of dancers, cafés at night. In his approach to these subjects he was influenced by Japanese prints — by the care with which Japanese artists placed their subjects in relation to the frame, and by their ruthless use of that frame to cut off a scene in the middle of a figure or an object. Photography also has its influence through its ability to capture the unexpected angle and cut a random square out of reality. His interest in modern life

led Degas, in the late 1860s, to abandon historical subjects and turn, first to scenes of life on the racecourse, and then increasingly to scenes of theatrical life — of musicians and above all of dancers. In 1874 Edmond de Goncourt visited Degas's studio, recognized the influence of *Manette Salomon* in his paintings of dancers and laundresses, and commented that 'he is the man I have seen up to now who has best captured, in reproducing modern life, the soul of this life.'

In 1876 Degas lost most of his fortune and began to depend on selling his paintings. This financial necessity came into conflict with his unwillingness to part with his work, an unwillingness that arose from a perfectionism that drove him to return to paintings, even after an interval of years, in order to improve or destroy them. Fortunately he found in pastel a medium less formal than oil. In his later years he used it almost exclusively, achieving a freedom, spontaneity,

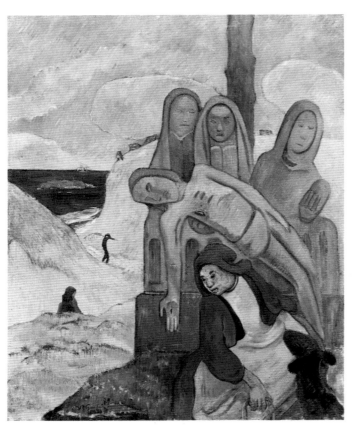

and daring in his use of colour that are surprising in an artist who professed to believe in the exclusive value of line.

In the 1882 Impressionist exhibition he exhibited a series of pastels, the 'nudes of women bathing, washing, drying, rubbing down, combing their hair or having it combed'. Of such pastels Degas wrote, 'this is the human animal busy with itself.' He wanted to present the nude not as it 'had always been presented, in poses which presuppose a audience', but in a natural way 'as if you were peering through the keyhole'. It is in works like these that his fundamental, though hidden, links with Impressionism become apparent.

On the surface Degas was opposed to Impressionism in all things. 'You need natural life,' he told the Impressionists, 'I, artificial life.' They were interested in colour, he in line, they tried to paint on the spot what they saw in front of them, he from memory in the studio trying to liberate his 'recollections and inventions . . . from the tyranny which nature exerts'. But deep down he shared with the Impres-

Gauguin: *Calvary*, 92 × 74cm, 1889

BELOW **Gauguin:** *Breton Landscape*, 72 × 91cm, 1889

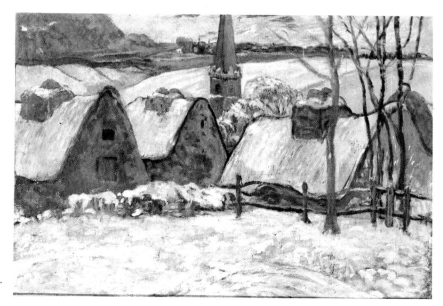

Gauguin: *Breton Village under Snow.* 62 × 87cm.
1894

sionists an interest in fixing on canvas certain fleeting aspects of reality that had never been caught before. His belief in the value of line made him admire Ingres, but, unlike Ingres, unlike any of the establishment painters, he replaced composition by selection. With his dancers and his women in milliners' shops, as with his nudes, he did not pose the models, but instead observed them carefully as they went about their business. Then with a miraculous instinct he chose the precise viewpoint, the precise field of vision, and above all the precise moment in the seamless continuum of movement, whether of a woman getting out of a tub or of dancers moving across a stage, in which every line is united in perfect harmony.

Degas, thus, can be seen as an Impressionist who realized

that to train the hand to transcribe the perceptions of the eye as they were received was, even when Monet took it to its logical conclusion by working on a canvas for as little as ten minutes at a time, inevitably to falsify changes that occur second by second. Instead, he trained his mind to snip from the reel of his visual memory the truly instant impression that satisfied him.

Among those who were influenced by Degas' solution to the impossible dilemma of the naturalist were the young American painter, Mary Cassatt, who said, 'The first sight of Degas's pictures was the turning point of my artistic life,' and Toulouse-Lautrec.

Count Henri de Toulouse-Lautrec was born in 1864 to an ancient and aristocratic family. His early work shows the generalized influence of Impressionism, but, as he said in 1891 when interviewed by Jules Huret, it was the work of Degas and Forain that he admired most. In his early ballet

Gauguin: *Breton Landscape*
Gauguin: *Calvary*
Gauguin: *Breton Village under Snow*
Gauguin: *Vairumati*

From 1876, when he met Pissarro, Gauguin painted in the Impressionist style. After leaving his job as a stockbroker's clerk and an unsuccessful attempt to find employment in Copenhagen, he devoted himself to painting. By 1886 he was becoming dissatisfied with a technique that allowed him only to describe what he saw before him. He went to Pont-Aven in Brittany, where he found a wildness and a primitiveness sympathetic to his temperament. In 1888 after a visit to Martinique he went back to Brittany and worked with Émile Bernard, who helped him to break more radically with naturalism. Although he continued to paint landscapes he also did a series of paintings of religious themes. *Calvary* is based on the moss-covered *Pietà* from the Calvary of Nizon. Through paintings such as this he tried to 'capture the great rustic and superstitious simplicity' of the sculpture. Here colour bears no relation to reality: it is used for its expressive and emotional qualities. He was very excited by the qualities of primitive art, and in April 1891 he set out for Tahiti in search of new themes and ideas. He lived there, except for a short spell in France, until his death in 1903.

Gauguin: *Vairumati.* 72 × 94cm. 1897

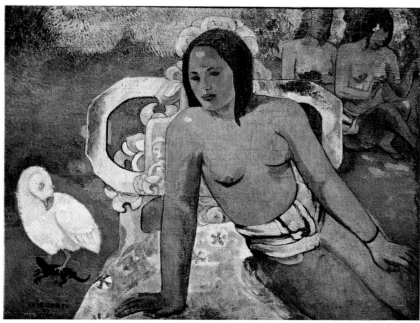

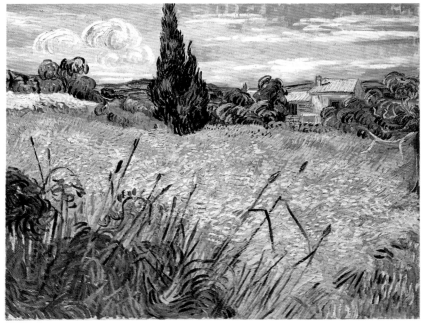

Van Gogh: *Green Wheat*, 73·5 × 92·5cm, 1889

Van Gogh: *Green Wheat*
Van Gogh: *The Chair and the Pipe*
Van Gogh: *The Bedroom of Van Gogh at Arles*

While van Gogh was under treatment at Saint-Rémy hospital he painted his room at Arles from memory. In a second painting of the same subject, in the Rijksmuseum, the composition is in every respect the same, but the colours do not have the same vibrancy. Like Gauguin he uses colour for its expressive qualities to work out his own inner emotions and to impart a strength and dignity to the most commonplace objects such as the chair in *The Chair and the Pipe*. In his own words 'the colour should impart, by its simplification, a grander style to things'.

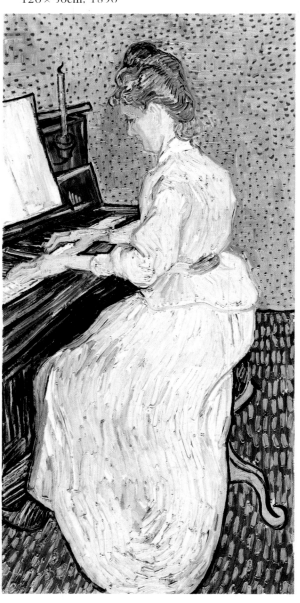

Van Gogh: *Marguerite Gachet at the Piano*, 120 × 50cm, 1890

the task of 'making out of Impressionism something solid and durable like the art of the museums'.

During these years he was largely forgotten, though never by Pissarro, who wrote to Huysmans in 1883 that 'all of us recognize [Cézanne] as one of the most outstanding and curious temperaments of our time and one who has had a very great influence on modern art.' It was not until Ambroise Vollard, persuaded by Pissarro, gave Cézanne a one-man show in 1895 that his reputation began to grow. Though rejected by the critics, he became a hero to younger artists, among them Maurice Denis, who exhibited *Hommage to Cézanne* at the Salon of 1901. To Émile Bernard Cézanne said, 'see in nature the cylinder, the sphere, the cone.' It was

Van Gogh: *The Bedroom of Van Gogh at Arles*, 56·5 × 74cm, 1889

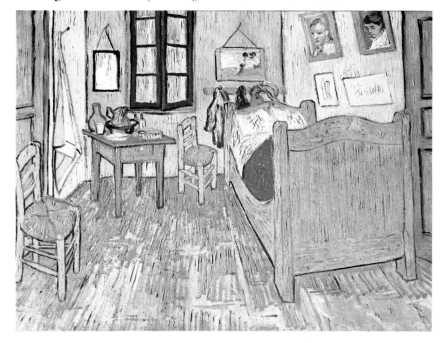

OPPOSITE **Van Gogh:** *The Chair and the Pipe*, 92 × 73cm, 1888–9

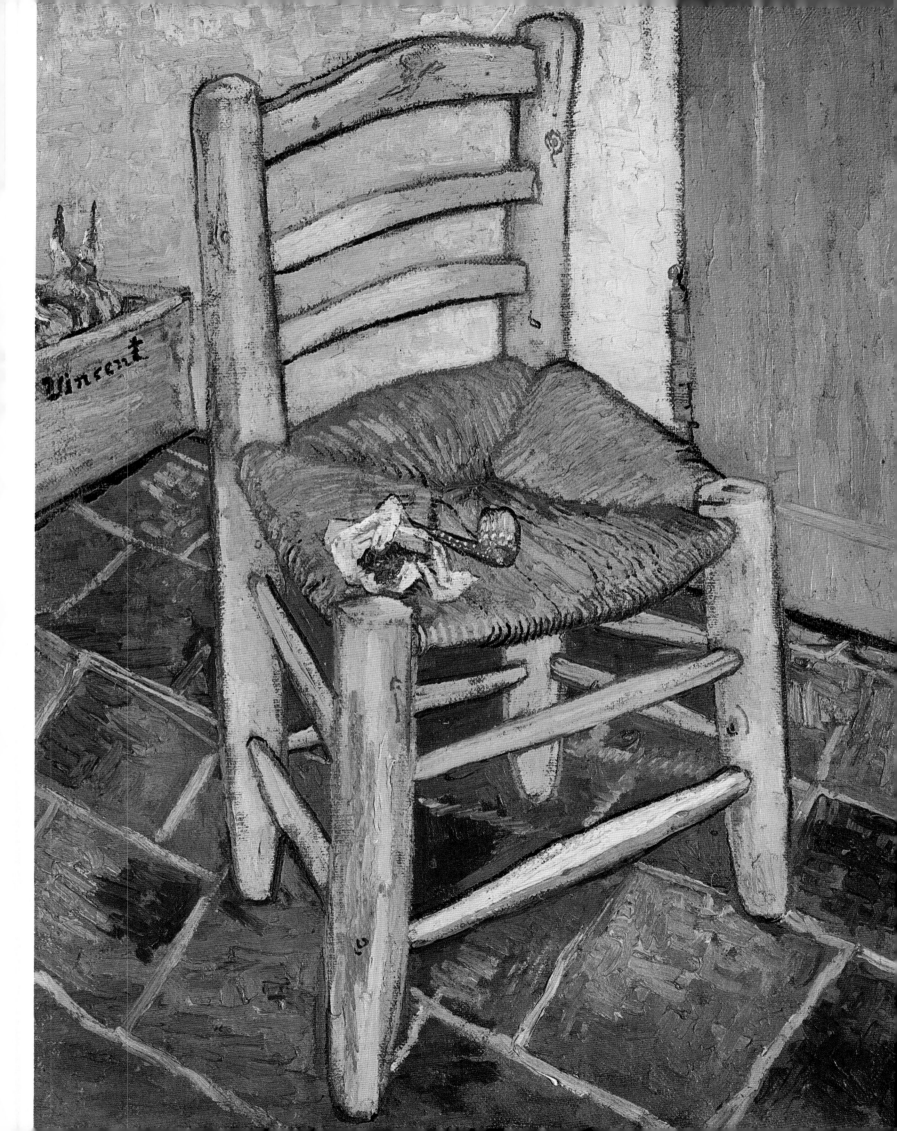

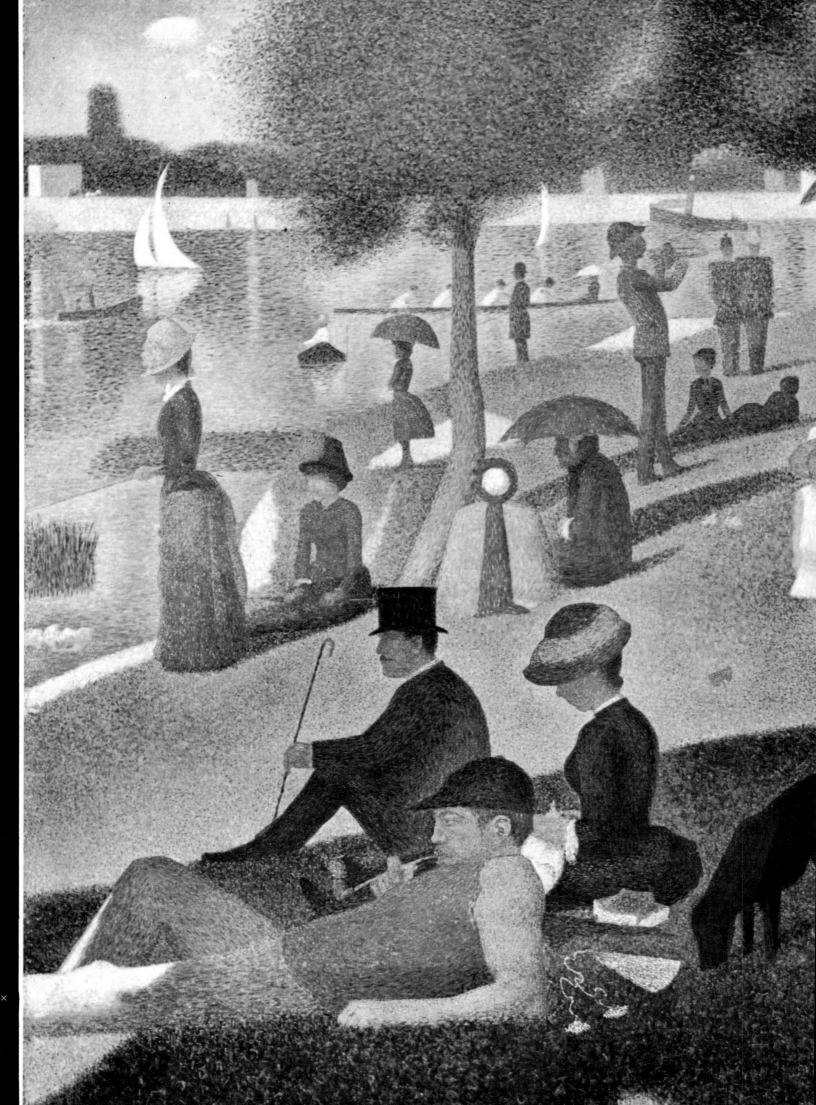

Seurat:
Sunday at Grande-Jatte. 206 × 305cm, 1884–6

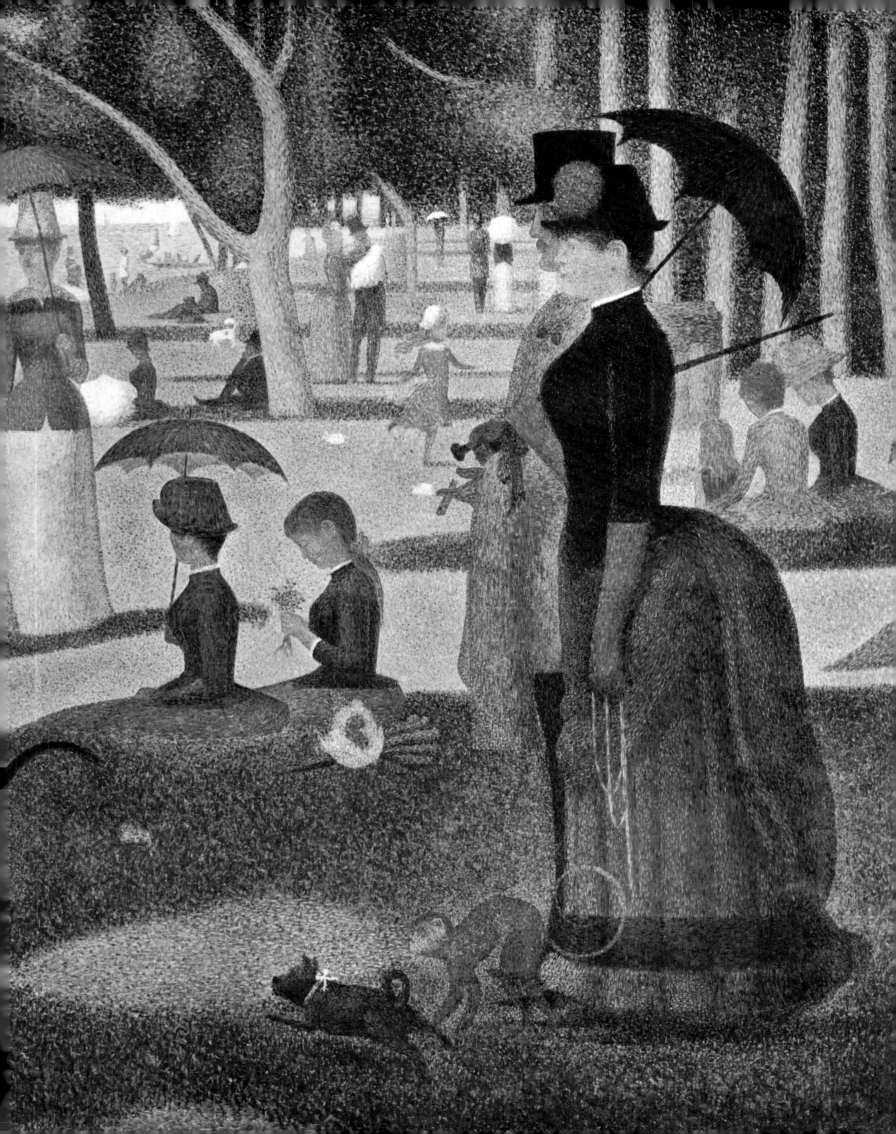

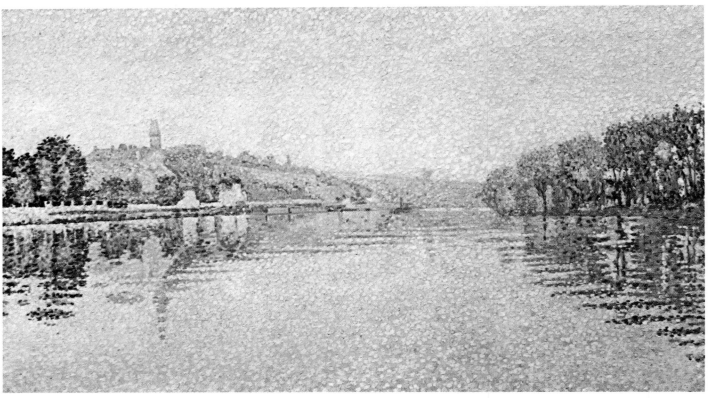

Signac: *The Seine at Herblay.* 33 × 55cm, 1889

his ability to transcend the style of Impressionism, to go to the structure that lies behind visual appearance, and his magically delicate colour harmonies that, by appealing to painters like Picasso and Braque, had a central role in the development of twentieth-century art.

Though nine years younger than Cézanne, Gauguin too has some claim to have been involved with the Impressionists from an early stage. Born in 1848, he worked as a stockbroker's clerk in Paris from 1871. He began to paint in his spare time and in 1876 started buying Impressionist paintings. At about this time he met Pissarro, who developed his talent as he had Cézanne's, by bringing him into close contact with nature.

Gauguin painted with Pissarro and later with Cézanne at Pontoise, participated in the Impressionist exhibitions from 1879, and even in landscapes painted during his later, Symbolist, period, such as *Calvary* and *Vairumati,* was still using an Impressionist brushstroke and technique. From 1886, however, he had begun to break away from the influence of Impressionism. He started to work indoors and to

Seurat: *The Port of Honfleur,* 53 × 64cm

Seurat started his career with a conventionally academic training but was receptive to the ideas behind Impressionism. He adopted their style of painting in the open air and was particularly interested in their colour theories. He began to feel that Impressionism was too casual in its approach, and wanted to develop a more scientific and structured style of his own. He became interested in the colour theories of Chevreul and Rood, and his paintings reflect the highly organized way he set about the task of applying their theories to art. In *Bathing at Asnières* we see how he moves towards a new technique: with his subtle eye for colour he uses light criss-cross strokes to depict the grass. In the detail of the boy's hat we can see how he has juxtaposed small dots of colour to represent the way that the orange of the sun, the blue of the sky and the complementary of the colour of the object casting the shadow are all present in the shadow. In order to show such effects with the maximum precision he began to use a pointilliste technique for the first time on a large scale in the *Grande-Jatte*. Both of these canvases were executed in the studio from small oil sketches done out of doors – another break with Impressionism – and one that allowed him to achieve an absolutely calculated and almost hieratic effect.

Signac was a friend of Seurat and adopted Seurat's colour theories. At the last Impressionist exhibition these two, together with Pissarro, exhibited work in the Divisionist technique.

Seurat: *The Banks of the Seine.* 65 × 82cm.

believe that his inner experience was more important than any experience of nature. This led him, in paintings like *Calvary*, to adopt a decreasingly naturalist approach. The view he began to develop – developed further by others after he dropped out of French artistic life into isolation in the Pacific – that the artist can and should use colour and form to express himself rather than to represent the outside world, is, of course, the absolute opposite of Impressionist doctrine. It was through this reaction to Impressionism that artists moved away from representation toward an increasing belief in the value of abstraction.

Vincent van Gogh was the third great painter to be in-

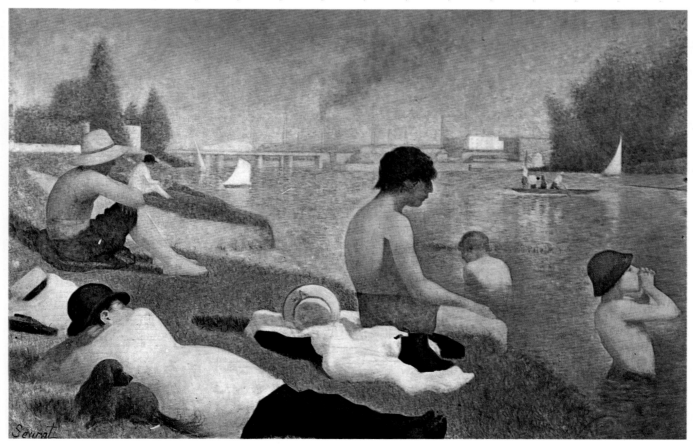

Seurat: *Bathing at Asnières,* 203 × 302cm, 1883

fluenced by Pissarro. When van Gogh came to Paris in 1886 he met Pissarro, and because of him van Gogh abandoned the dark palette and gloomy figure compositions, which characterized his work in Holland, in favour of the bright colours and Impressionist brushstroke that he used for his views of Paris in 1886–7, such as *The Restaurant de la Sirène*.

In 1888 van Gogh went to Arles. Tremendously excited by the vivid colours he found under the bright sunlight of the south, he turned away from the objectivity that was an essential element of Impressionism. To ignore his own feelings, to record what he saw to the exclusion of what he felt,

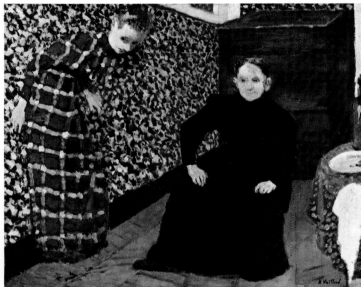

Vuillard: *The Artist's Mother and Sister*, 45 × 55cm

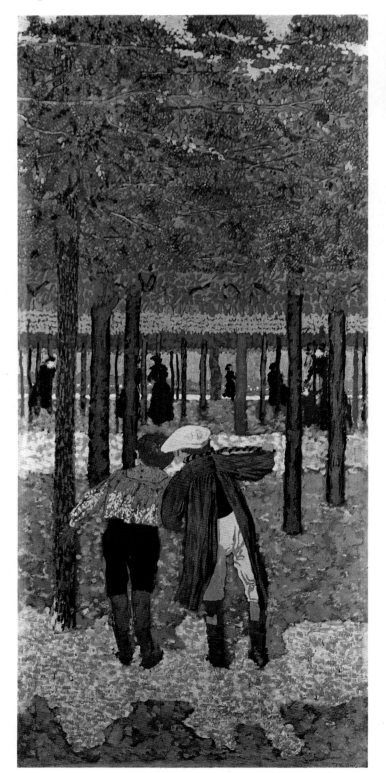

Vuillard: *The Artist's Mother and Sister*
Vuillard: *Interior with a Seated Woman*
Bonnard: *Interior at Antibes*
Bonnard: *The Table*

Bonnard and Vuillard, together with Maurice Denis and Paul Sérusier, formed part of a group called the Nabis, who were much influenced by the abstract tendencies in Gauguin's work in Pont-Aven around 1889. Despite its initial daring, their work tended to revert to a variety of Impressionism from the mid-1890s. Vuillard's interiors are perhaps the most successful attempt to apply an Impressionist approach to the depiction of bourgeois Parisian interiors. In *The Artist's Mother and Sister* and *Interior with a Seated Woman* he shows his love of patterned wallpapers and carpets. His mother and sister seem oppressed by their surroundings and reduced to the same level of impotence as the patterns around them.

Bonnard also painted interiors, though with a gaiety and love of colour that are absent in Vuillard's work.

LEFT **Vuillard:**
*The Two
Schoolboys,*
214 × 98cm

RIGHT **Vuillard:**
*Interior with a
Seated Woman,*
44 × 38cm,
1904–5

was quite impossible for this most passionate of men. He felt that he was compelled, even against his will, to express himself through exaggeratedly violent clashes of colour. Of his *Night Café*, painted in September of that year, he wrote: 'I have tried to express in this picture the terrible passions of humanity by means of red and green . . . The colour is not locally true . . . it is a colour suggesting some emotions of an ardent temperament.' In *Van Gogh's Room at Arles* or *Chair with a Pipe* van Gogh reveals his inability to be objective.

Bonnard: *Interior at Antibes*, 105 × 121cm, 1920

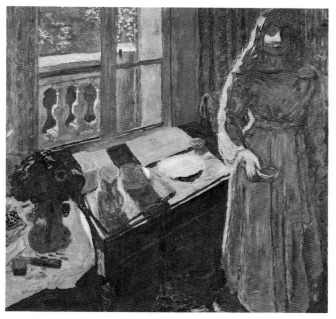

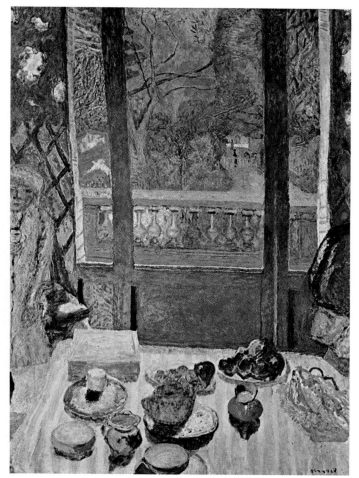

Bonnard: *Dining Room: Garden View*, 167 × 110cm

Gauguin produced a theoretical rejection of Impressionism, but its inherent limitations as a theory of art were shown more clearly by van Gogh's paintings.

As an approach to the representation of nature Impressionism has had few equals, and as a force for the liberation of art, its role cannot be overestimated. Indeed the prolonged rejection of the Impressionists has been the primary reason why the view that great art comes from the development of tradition was replaced by the assumption that it emerges from rebellion against tradition. Moreover, both Cubism, in its concern for representing, in a single image, the reality that we see an object from changing viewpoints, and Futurism in its attempt to picture the reality that objects move in space and time, drew inspiration from the naturalist ideal. But it is also true that, in deliberately attempting the impossible, the Cubists and the Futurists intended to produce images whose impact does not depend on their success as naturalistic representations of reality.

Bonnard and Vuillard were proper followers of Impressionism, followers who were to extend the Impressionist technique to subjects, interiors and figure studies, which had not previously been fully explored. Yet they stood quite apart from the mainstream of twentieth-century art, and it is difficult to escape the conclusion that, in Impressionism, the development of the naturalist tradition in Western art came almost to a dead end.

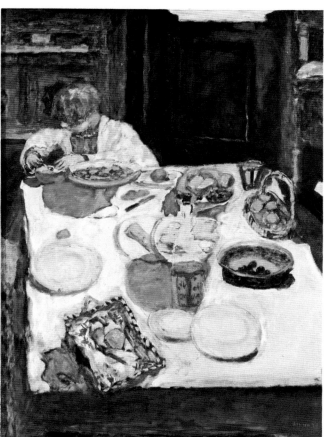

LEFT **Bonnard**: *The Table*, 103 × 74cm, 1925

Bonnard: *Mother and Her Son,*
33 × 42cm

Bonnard: *The Seine at Vernon*, 105 × 105cm

The Late Work of Pissarro, Renoir and Monet

Several years before he met van Gogh, Pissarro had, like Cézanne and Gauguin, begun to look for a way forward from Impressionism. In 1885 he met a much younger painter, Georges Seurat (born 1859). Seurat, though influenced by the Impressionists, whose technique he adopted in his early oil sketches from nature, had exhibited an extraordinarily original work, *Bathing at Asnières*, at the first exhibition of the Society of Independents in 1884. This contained, to the full, that classical solidity and structure that Pissarro, like Renoir, felt to be lacking in Impressionism. Seurat went on

RIGHT **Bonnard**: *Nude against the Light*, 122 × 35cm
BELOW **Bonnard**: *Nude against the Light*, 125 × 109cm, 1919–20

Bonnard: *The Seine at Vernon*
Bonnard: *Nude against the Light*

In some of his landscapes Bonnard like Vuillard seemed concerned to weave the elements of the scene together into a kind of tapestry. In his late works, and in particular in his series of paintings of his wife, standing naked or in the bath, he achieved an entirely personal variety of Impressionism. In his analysis of light or naked flesh it truly seems, as hostile critics had said of Renoir's work many years earlier, that the flesh is decomposing, but not, as a critic had implied, into a lump of rotting meat, but rather into a marvellously harmonious series of related tones of colour.

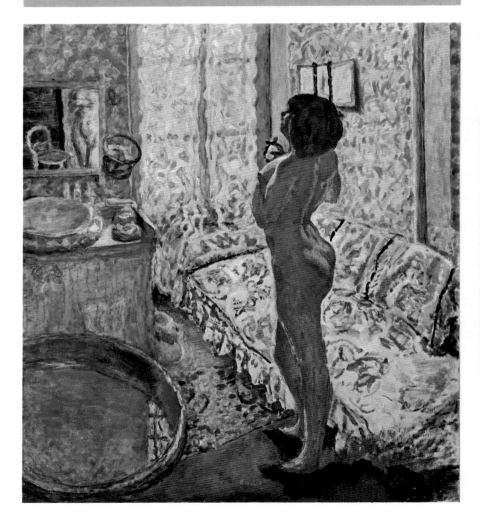

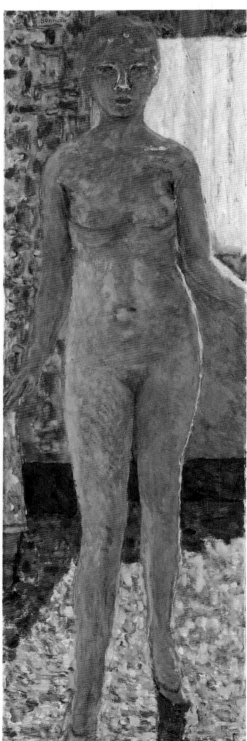

OPPOSITE **Bonnard**: *Nude against the Light* (detail)

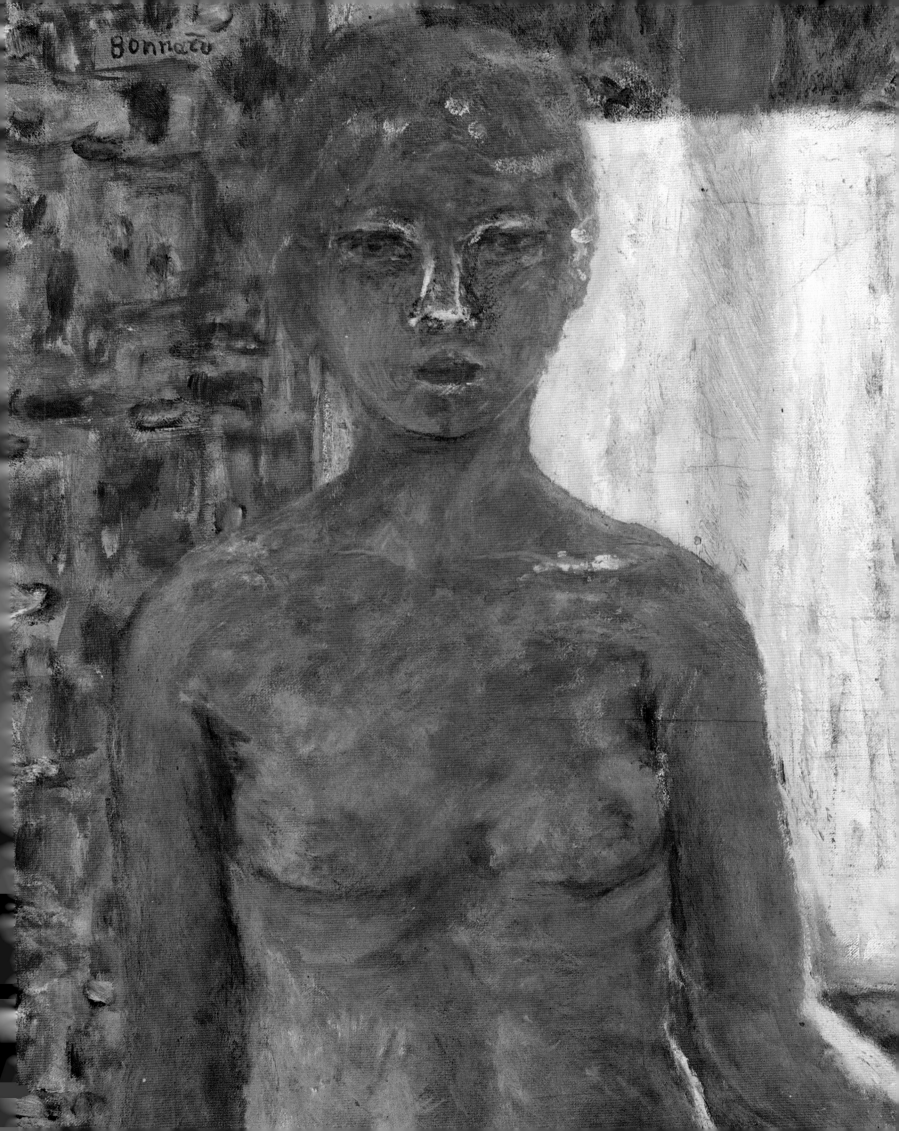

to develop a theory that if, instead of producing a particular tone by mixing colours on the palette, the painter applied dots of pure colour on canvas in the correct proportion, then at the right distance the dots would fuse to produce the desired tone by optical mixture (as they do for example in a colour reproduction, which is made up of minute dots of primary colours). This optical mixture would, he believed, produce clearer and more vibrant colour than could be obtained by mixture on the palette.

This theory, called Divisionism, combined with a Pointilliste technique, offered the perfect antidote to the 'unpolished and rough execution', which had been worrying Pissarro, and a progressive and scientific approach to painting that very much accorded with his political inclinations. Though already in his fifties, Pissarro plunged with enthusiasm into the new technique, explaining to Durand-Ruel that he sought 'a modern synthesis by methods based on science'.

In 1886 he secured Seurat's aid and Signac's participation in the last Impressionist exhibition. But despite the artistic success of works like *La Grande-Jatte*, which was shown there, or the *Port of Honfleur*, Pissarro was unable to follow Seurat into the wilder reaches of his theories about the emotional value of different types of line. Instead, feeling increasingly restricted by the impersonality of the Pointilliste technique, he abandoned it in 1890 and returned to further exploration of the possibilities of Impressionism.

Renoir, like Pissarro, felt in about 1883 that he 'had gone to the end of Impressionism'. In an effort to overcome the feeling that he no longer knew 'how either to paint or to draw' he began to value line rather than colour and returned to

studying the art of the past. He concentrated on painting nudes and portraits rather than landscape, and having gone through a period of rigid classicism, emerged into an enormously decorative, though sometimes rather facile, late style, which was a conscious attempt to develop the tradition of eighteenth-century French art. 'Nature', he said, 'brings one isolation. I want to stay in the ranks.'

Monet too became deeply dissatisfied with his art in about 1883 but, unlike Renoir and Pissarro, he never really wavered in his belief that Impressionism was the right path. As a result, his painting develops with a single-minded logic that is lacking in the other artists' work.

In his depictions of the countryside around his home at Giverny, in the Seine valley, Monet became increasingly concerned that he should not falsify his impression of a scene by continuing to work on it when the light had changed. According to a journalist who watched him at work this meant that he was frequently unable to spend more than an hour on any particular canvas. It was perhaps a natural consequence, that instead of lugging canvases and easel to a new spot every few minutes, he started to paint the same scene under different conditions of light. He thought that the haystacks, which he first chose to study in this way, would need only two canvases, one for cloud and one for sun, and was amazed that he had to keep sending his stepdaughter back for more canvases as the light changed. What is certainly true is that in the succeeding series, of poplars by the river, of Rouen Cathedral, London, Venice, and above all the water garden which he had created in the grounds of his home, he became increasingly concerned with what he

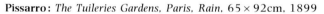

Pissarro: *The Tuileries Gardens, Paris, Rain,* 65 × 92cm, 1899

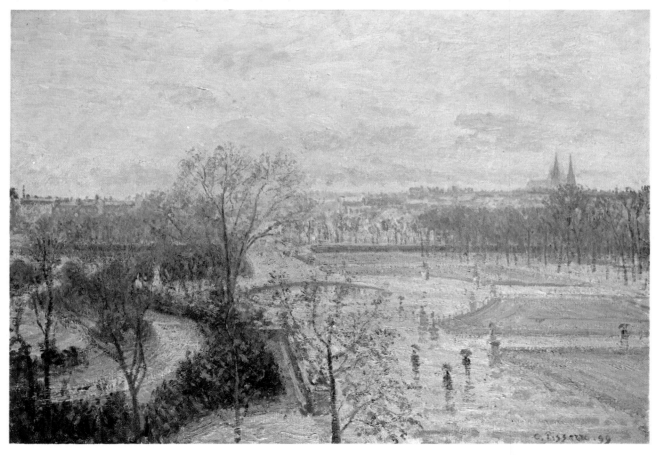

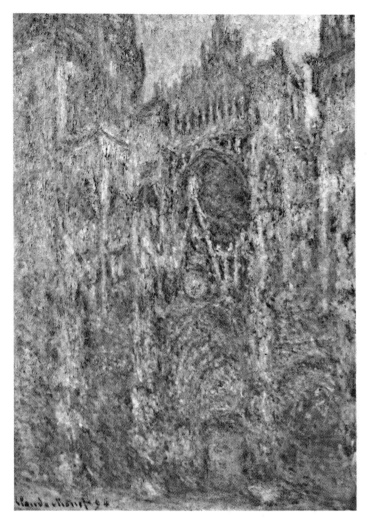

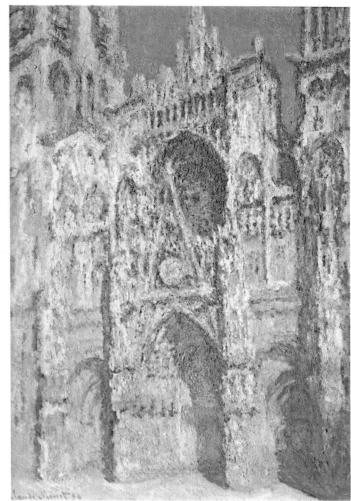

called 'instantaneity', the impression of an instant, and so he worked on ever increasing numbers of canvases at the same time. By 1897, when he was working on the *Morning on the Seine* series, he had fourteen canvases by him, in the open air, ready to switch from one to the other as the light changed.

John Rewald has written of this approach to the fundamental problem of Impressionism that Monet's 'eyes, straining to observe minute transformations, were apt to lose their perception of the whole', and it is true that, in his unswerving dedication to one idea, he did train himself to become unaware of form. Such an intention is implicit in his remark that he wished he had been born blind and then gained his sight, for by this he meant that only a person who has never seen can transcribe undifferentiated visual sensations without being unconsciously influenced by what he knows — that a certain set of sense impressions signifies a tree, another set a house and so on.

In his search for the instant impression and the perfect transcription of it Monet had, paradoxically, to abandon some of the dogmas of Impressionism. The selection of the right motif for the series paintings was of the greatest importance, and in the end he created the perfect motif, the water garden, artificially. Increasingly, paintings that were begun on the spot were finished in the studio, indeed it would have been impossible to paint the vast Nymphéas series outside it, and it must have begun to seem to Monet,

Left **Monet:** *Rouen Cathedral in the Sunlight*, 100 × 66cm, 1894
Right **Monet:** *Rouen Cathedral, the Door and Tower of Saint-Romain, Full Sunlight*, 107 × 73cm, 1894

These paintings of Rouen Cathedral belong to one of a series of studies of the same subject that Monet undertook from the late 1890s to the end of his life. Other subjects included a haystack and a line of poplars. His idea was that, by coming back to the same subject in different conditions of light, you would gradually come nearer to capturing a truly instant impression. It would not in any sense be a synthesis in which different parts of the composition were painted in slightly different conditions. By recording and even perhaps exaggerating the difference that changing conditions of light produced he trained himself to the highest peak of sensitivity to their effect.

as to Degas, that the truest image was the one that stayed in the memory.

These moves were not so much breaks with Impressionism as necessary developments of its technique in order to come nearer to its goal. Another natural development was that, particularly in the series paintings, the Impression became the subject, and the motif merely the means to it. The late paintings work on two levels. From a distance they are astonishingly accurate representations of parts of reality; it

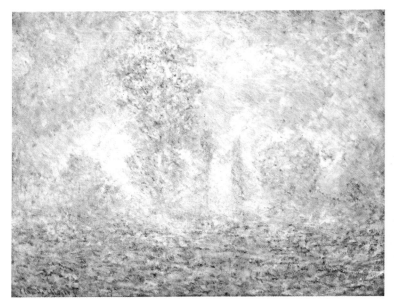

Monet: *Morning Fog,* 74 × 93cm, 1892

Monet: *Rainbow over the Pond,* 200 × 253cm

seems, for example, almost impossible for Monet to have captured on canvas a scene reflected in water through which waving plants are visible. From close to the paintings are a maze of brushstrokes that seem to have been applied with a view entirely to their abstract relation one to another.

As Monet grew older he became more interested in the painting as object rather than as representation, and indeed, in the end, when his sight no longer allowed him to stand back and see the whole, as he used to do, the immediate surface became of paramount importance to him. The late paintings, which have inspired twentieth-century artists from Kandinsky to the Abstract Expressionists, represent the final paradox of Impressionism. At the moment when Monet after a lifetime of struggle came nearest to being able to transcribe his impression of nature onto canvas he was also on the verge of abandoning the impression. His last paintings seem about to break through to the ultimate naturalism — the point at which the paint in its own right becomes more important than what it represents, so that, at last, the picture is exactly what it seems to be.

Monet: *Waterlilies* (detail)

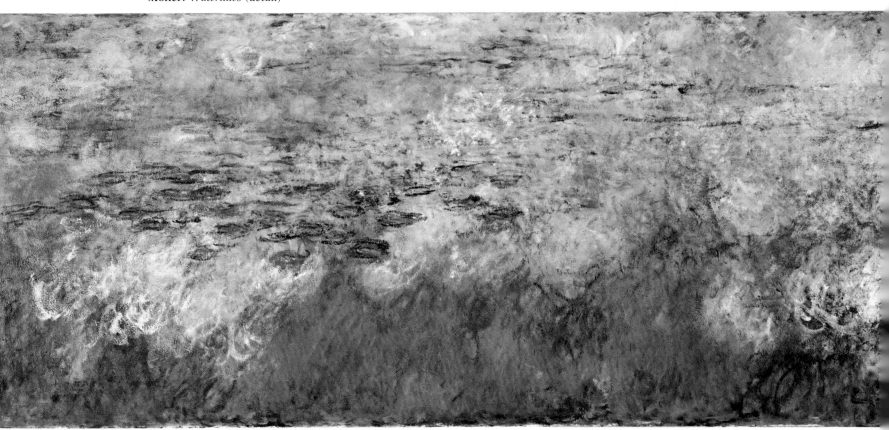

Monet: *Morning Fog*
Monet: *Rainbow over the Pond*
Monet: *The Waterlily Pond*
Monet: *The Waterlily Pond*
Monet: *Waterlilies* (detail)

In 1893 Monet bought a strip of land between his property at Giverny and the river Ru. There he created a lily pond bridged by a Japanese-style footbridge, which became one of the favourite subjects for his paintings. By 1897 he had decided to do a large series of studies of waterlilies and he was to work on this idea on and off for the rest of his life. He showed different series of the lily pond paintings at Durand-Ruel's gallery in 1900 and 1909. In 1915 he had a new and enormous studio built and started work on a final series painted on huge canvases, which Georges Clemenceau persuaded him to give to the French nation and which are today housed in the Orangerie in Paris. These are a supreme triumph and represent the synthesis of a lifetime's experience in one great decorative scheme.

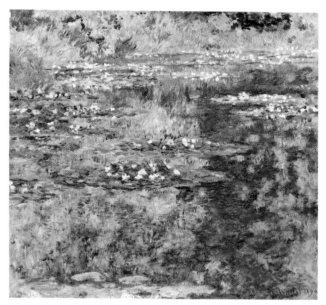

Monet: *The Waterlily Pond.* 90 × 92cm. 1904

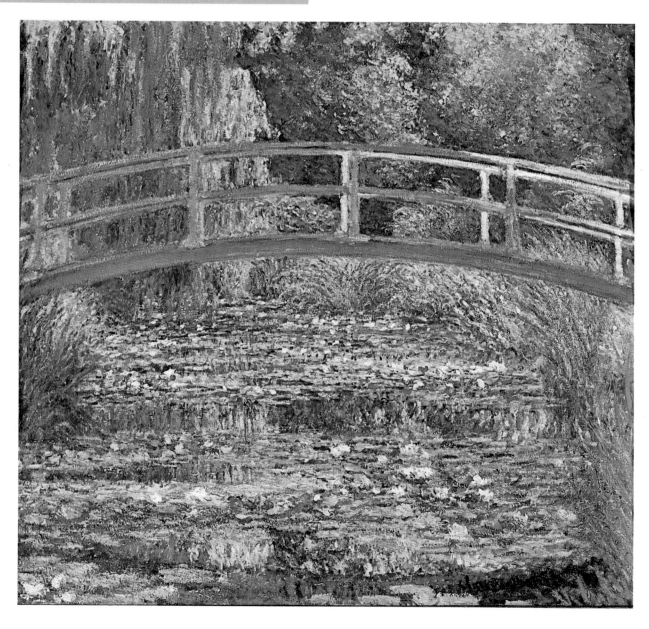

Monet: *The Waterlily Pond.* 88 × 92cm

Monet: *The Japanese Bridge,* 89·2 × 116·2 cm, c.1923–5

List of Illustrations

Bibliography

REWALD, JOHN: *The History of Impressionism*, 4th rev. ed., 1973
REWALD, JOHN: *Post-Impressionism from van Gogh to Gauguin*, 2nd ed., 1962
POOL, PHEOBE: *Impressionism*, 1967
Monet's Years at Giverny, Metropolitan Museum of Art, New York, 1978